IMAGES
of America

BECKLEY

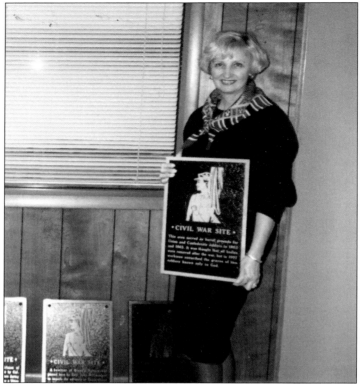

The Civil War began on April 12, 1861, when a single mortar round was fired on Fort Sumter, South Carolina. From this war, a new state was created. Pres. Abraham Lincoln proclaimed West Virginia would join the Union on June 20, 1863. Although no major battles were fought in Beckley, Company A of the 23rd Ohio Volunteer Infantry occupied the town from 1861 to 1863. Six documented sites are now marked with bronze plaques throughout Beckley. Author Fran Klaus implemented this project, as well as numerous other historical endeavors in Beckley. Fran is committed to preserving the images and stories of Beckley's past.

ON THE COVER: Lyric Theater opened its doors to silent films in 1920, on the southwest corner of Neville and Heber Streets in Beckley. Professional violinist Lorraine Lindoft Wasson was hired to play the violin during the silent film era at the Lyric in 1928. The masked man standing on the running board of the touring car is thought to be promoting the movie featuring Mel Ray as an illusionist. Ending the silent film era, *Talkies* began in 1929. The Lyric Theater closed its doors in 1959. (Courtesy of Emmett S. Pugh.)

IMAGES
of America

BECKLEY

Fran Klaus

ARCADIA
PUBLISHING

Published by Arcadia Publishing
Charleston, South Carolina

Printed in the United States of America

Library of Congress Control Number: 2011932308

For all general information, please contact Arcadia Publishing:
Telephone 843-853-2070
Fax 843-853-0044
E-mail sales@arcadiapublishing.com
For customer service and orders:
Toll-Free 1-888-313-2665

Visit us on the Internet at www.arcadiapublishing.com

To Zachary, Benjamin, Joshua and Allison:
Wishing you God's blessings from the past for a safe
journey into the future. Enjoy the ride!

CONTENTS

ACKNOWLEDGMENTS

A renewed interest in local history has prompted this publication, which, with the technical assistance of Frank Manello, will be appreciated for generations. "Lest we forget from whence we came," as the saying goes.

With special thanks to Lisa McMillion of the *Register-Herald*, who provided an avalanche of interest with an article requesting photographs from the public. I thank Kevin Traube of The Little Brick House for bringing Arcadia Publishing to my door and for his encouragement to make this happen.

Tom Sopher and the Raleigh County Historical Society provided a number of photographs that made a valuable difference in the variety of Beckley's memories.

Scott and Cindy Worley wrote the intriguing introduction. My sincere appreciation goes to the members of the Raleigh County Historical Society, who participated in any way to the success of this endeavor.

Russ Parsons offered his amazing collection of photographs without reserve. Thank you, Russ! I truly appreciate Robert Hancock's collection of Skelton Coal Camp photographs and his remarkable recollection of events from the 1930s and 1940s. Joe Fourney was the first to provide a great assortment of photographs from 1942, giving me the incentive to get this project started. Thanks, Joe!

I also thank Joe Guffy and Ellen Taylor of the Raleigh County Chamber of Commerce, Mayor Emmett Pugh, David Fuerst and Andrew Steel of the National Park Service, Kevin Price of Beckley Fire Department, and many others who researched and shared photographs and family histories for future generations to ponder.

This publication would not have happened without the love and support of my husband, Dick, who has patiently endured my perpetual projects. Amy Perryman and James Wright, editors at Arcadia Publishing, guided me through a maze of technology with great patience, and I thank them for the opportunity to preserve Beckley's pictorial history.

Unless otherwise noted, all images appear courtesy of the author. Contributions from Raleigh County Historical Society will be noted as RCHS.

The following sources proved invaluable in documenting photographs: *Beckley USA* by Harlow Warren, *Raleigh County West Virginia* by Jim Wood, *Centennial Year*, magazines, newspapers, *New River Company History*, Raleigh County Library, the Internet, and a host of individuals.

The information was compiled in a manner to ensure maximum accuracy. However, I do not claim to be infallible and should there be mistakes, "put the blame on Mame, boys."

INTRODUCTION

People complain tirelessly about the winding, mountainous roads in West Virginia. That complaint is certainly not a new one, and the reality of roads, or lack thereof, kept Raleigh County undeveloped much longer than the surrounding areas. Other than occasional hunters, fur trappers, and land speculators with their survey teams, there were no permanent settlers in the area until around 1792. The major obstacle to settlement was the lack of transportation. The rivers could not be navigated and the terrain did not make building and maintaining roads easy or profitable.

But there was one road. In 1797, a six-foot-wide path was built by a group of land speculators. It was called Farley's Trace, and it ran from the mouth of the Bluestone River in what is now Summers County to modern day Louisa, Kentucky. The path of this road follows Route 19 and passes through the city of Beckley on Kanawha Street and Route 3. With the arrival of this primitive road came settlement.

The first areas of the county to be developed were Richmond District, Marsh Fork, and Shady Spring. Speculators acquired land grants and came to this wilderness to live, or sold tracts of land to individuals. Through the first few decades of the 19th century, a few dozen families settled into the area of Fayette County, now Raleigh County.

One of the most prominent of these newcomers was Alfred Beckley, who came to the area in 1836 to explore and improve the 56,679 acres he inherited from his father, John James Beckley, a prominent figure in early Virginia government.

In 1837, Alfred Beckley moved his wife, Amelia Neville Craig Beckley, and three children from Pittsburgh, Pennsylvania to Wildwood, a double log cabin built for him by John Lilly Sr. in 1835. In his journal, Beckley wrote that he had moved to a "perfect wilderness, full of deer, bear, swarms of pests so troublesome that we could not eat a meal without gnat smoke at every door." Beckley worked quickly to attract more settlers to this wilderness. By 1838, he had organized a group of investors to charter the Giles, Fayette, and Kanawha Turnpike, a wagon road originating near Pearisburg, Virginia, and ending at the salt works near Kanawha Falls. This route included portions of the old Farley's Trace. Other roads were quickly built with the Logan Turnpike that followed the route into Kentucky, establishing this area as an early transportation hub.

Also in 1838, Alfred Beckley drew his plan for a town comprised of 30 acres and had it chartered by the Virginia General Assembly. He christened his town Beckley after his father, John. The tiny city had a slow start. Beckley's first business did not open until 1848, when J. Cole, Blacksmith first opened. It was located at the junction of two turnpikes near where Kanawha Street and Main Street intersect today. Prior to that, the local residents sarcastically referred to the land as Beckley's "Paper Town." By 1860, the town's population had grown to about 165 with another 160 living in the vicinity.

In 1850, Beckley again approached the Virginia Assembly, petitioning to have a new county formed from a portion of Fayette, naming it Raleigh County. The county seat would become the new town of Beckley, no longer just a dream on paper.

The Civil War interrupted Beckley's growth. While there were no major battles fought in this region, both the Union and Confederate armies used the country roads to move troops and supplies. The Union army occupied the town, with future US presidents Rutherford B. Hayes and William McKinley as part of the occupying force.

The 1870 census shows Raleigh County's population to be 3,673, and new industries found their way into the area. Timber was the first major industry, as cutting and shipping timber supported the burgeoning railroad expansion across the country. These railroads did not penetrate Raleigh County until the early 1900s, increasing population dramatically.

It was no secret that coal was present throughout Raleigh County. Alfred Beckley wrote about outcroppings close to the surface in his early diaries. However, without an easy way to transport the coal to market, the industry did not gather a foothold until the railroad line was extended from Prince across the river to Fayette County and into Raleigh County in 1901. Coal mines sprang up as the railroad moved through the county. By 1907, the rail lines reached Winding Gulf coalfields that came to be knows as the "Smokeless Coal Capitol of the World."

As mines opened, communities appeared around them. Most coal mines were owned by mining companies, but nearly all had the same amenities, including stores, post offices, churches, doctors, schools, baseball fields, and theaters. Many of these communities only lasted as long as the mines stayed open. From the turn of the 20th century until the mid 1950s, Beckley became the commercial hub of Southern West Virginia.

Today, Raleigh County still depends on the coal industry for much of its financial system, but in recent years, tourism has become a major industry. The area's whitewater rafting, skiing, ATV trails, outdoor dramas, exhibition coal mine, national and state parks, and arts and crafts center attract tens of thousands of visitors annually.

One

BECKLEY'S

EARLIEST HISTORY

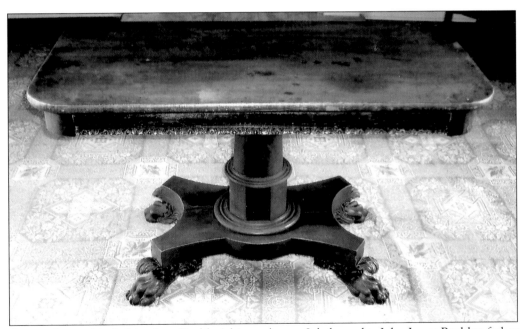

One might say this desk is where Beckley's history began. It belonged to John James Beckley, father of Beckley's founder, Alfred, who was born in 1802. John J. Beckley was a prominent figure in colonial history and was one of the founders of the Republican party. His signature is one of four appearing on the Bill of Rights. He was also a land speculator and obtained a patent for 170,038 acres in Raleigh County, then Montgomery County, Virginia. Alfred's inheritance amounted to 56,679 acres, which he moved his family to in 1836 and laid out his "paper town."

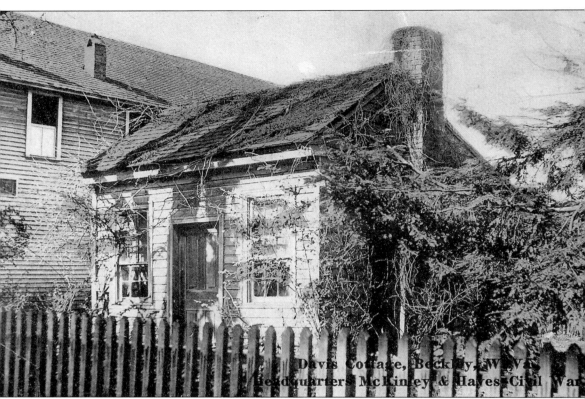

Davis Cottage, Beckley, W. Va.
Headquarters McKinley & Hayes Civil War

The home of Martha "Grandma" Davis was located on Main Street during the Civil War, just a few yards from the occupied Raleigh Court House. This was a convenient location for Gen. Rutherford B. Hayes and Gen. William McKinley to use as their headquarters in the winter of 1862. Mrs. Davis stated that her family was forced from their home and stayed with Alfred Beckley's family until the generals departed Beckley in 1863. The building, known as the Davis Cottage, was razed in 1917. (Courtesy of Russ Parsons.)

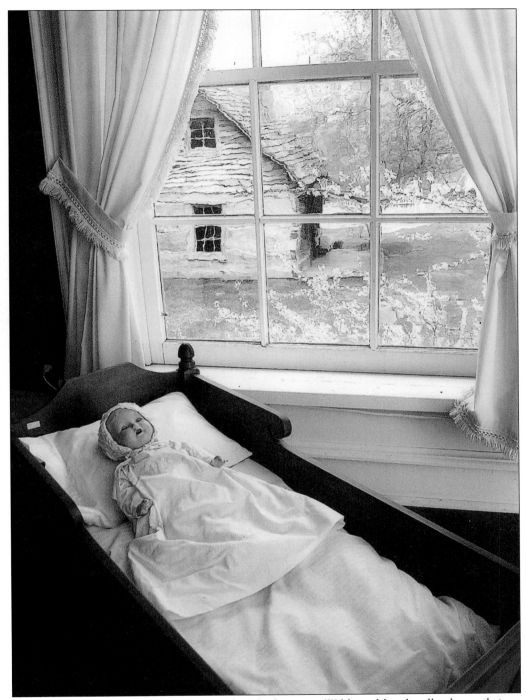

The view from Alfred and Amelia Beckley's bedroom at Wildwood has hardly changed since they looked out this same window in 1836. Even the wavy, distorted glass is the same. The cradle is said to be original to Beckley's home. It is on display at Wildwood Museum. (Photograph by Steve Brightwell.)

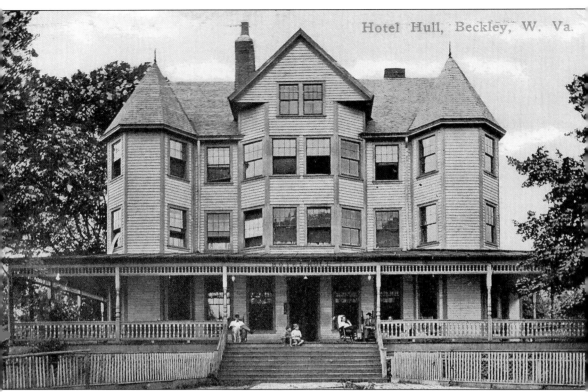

Hotel Hull was quite glamorous when John S. Hull built it in 1894. Located on the corner of Main and North Kanawha Streets, the hotel served as a social hub for weary travelers, salesmen, and vacationers enjoying the cool mountain summer breezes. It was also a popular gathering place for locals until it was razed by fire in 1912. The Beckley Hotel was built on this site in 1915. (Courtesy of Russ Parsons.)

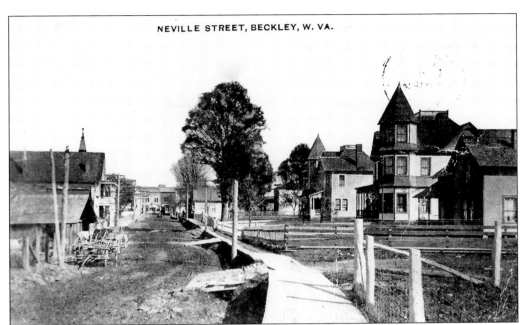

NEVILLE STREET, BECKLEY, W. VA.

Neville Street with the new boardwalks certainly must have delighted pedestrians in 1907. Timber was abundant and inexpensive in those days. These structures remained for the next four to five years and were replaced with concrete around 1911 or 1912. (Courtesy of Russ Parsons.)

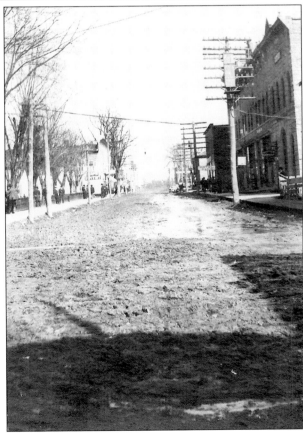

This photograph is of muddy Main Street. The rain and snow seasons played havoc with the ladies wearing long coats and dresses. Merchants of 1905 must have dreaded the wet seasons when their clientele tracked the mud from their boots and shoes into their establishments. (Courtesy of Russ Parsons.)

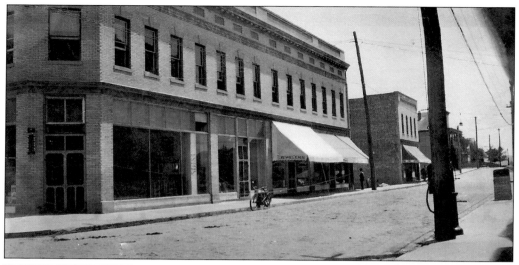

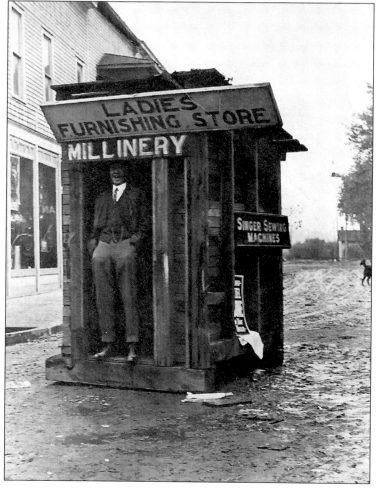

This corner of Heber Street is an icon, best remembered as the G.C. Murphy Company from the 1930s through the 1970s. It is shown as a two-story building, erected around 1915, and it is undetermined exactly when a third floor was added. Anyone who lived in Beckley will recall the delicious hot dogs from Murphy's. (Courtesy of RCHS.)

Halloween pranksters placed this structure in the middle of Heber and Neville Streets in 1911. This was, seemingly, an annual event as they created a lawyer's office, millinery shop, and a doctor's office from someone's outhouse. Standing in the doorway of this structure is Tommy Thompson. (Courtesy of Russ Parsons.)

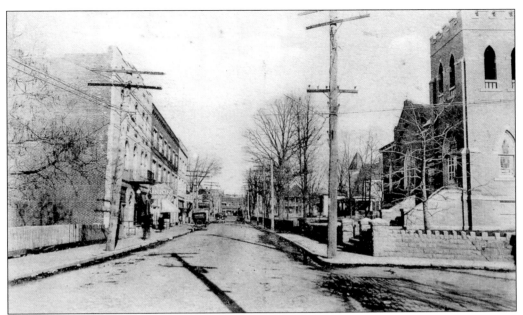

Neville Street was and remains the main thoroughfare through town. The street was named Neville in honor of Alfred Beckley's first wife's family. The Nevilles were prominent businesspeople in Pennsylvania. (Courtesy of Russ Parsons.)

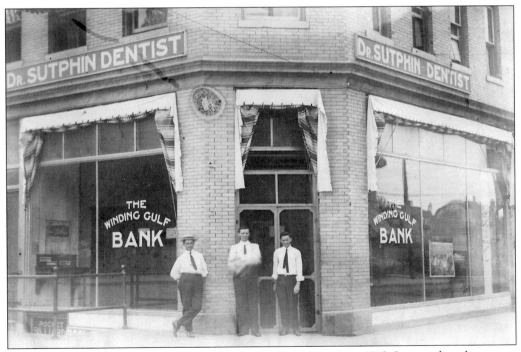

Winding Gulf Bank was organized in Hot Coal, West Virginia in 1913. It moved to the corner of Heber and Main Streets in Beckley on January 1, 1914. Having received a federal charter, the name was changed to Beckley National Bank in 1914. (Courtesy of RCHS.)

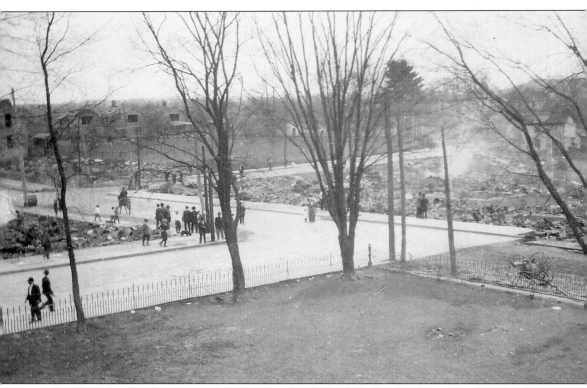

Beckley's first big fire occurred on Sunday, April 12, 1912, shortly after midnight. The fire was discovered on the corner of Neville and Heber Streets in the Rose-Turner building. It consumed 29 businesses and destroyed nearly four blocks of the downtown area. The streets that had recently been paved now lay in ruin. Damages amounted to approximately $275,000. Fortunately, no fatalities or serious injuries occurred. (Courtesy of Russ Parsons.)

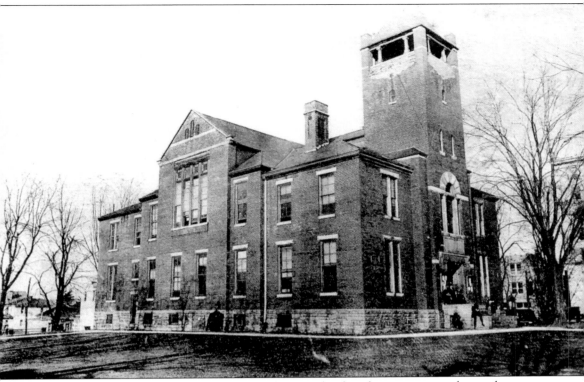

The first Raleigh County Courthouse sat on the same land as the current courthouse, but was much smaller. It housed a courtroom, clerk's offices, and a few smaller rooms. It was erected at a cost of $2,722 in 1852 and served until 1892. The second courthouse was built on the same site in 1893 and cost $34,354. It was razed in 1935. The third courthouse was then built on the same site in 1937 at a cost of $500,000 and remains functional as of 2011.

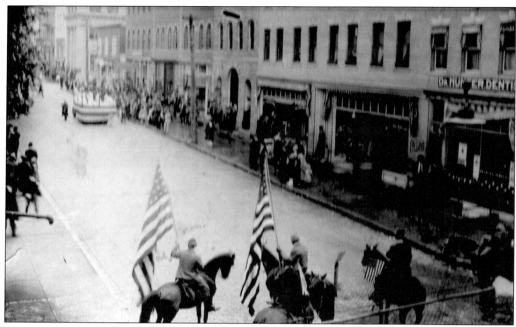

Main Street was fenced off at Heber Street to safely accommodate Democratic presidential candidate James M. Cox as he addressed the crowd in front of the Raleigh County Courthouse on October 25, 1920. Capt. James H. Lemon and Ernest Ewart are on their horses marshalling and flag bearing. Note the railing in the lower right where Pocket Billiards was located below ground. (Courtesy of Katherine Williams.)

Notice the newly laid brick streets on North Kanawha Street. This had been fertile farmland prior to 1900, explaining the lack of trees. The second house on the right sits on the corner of Wilson and North Kanawha Streets and is the current home of the Beckley-Raleigh County Chamber of Commerce. (Courtesy of Russ Parsons.)

Two

TRAINS, TIMBER, AND BLACK GOLD

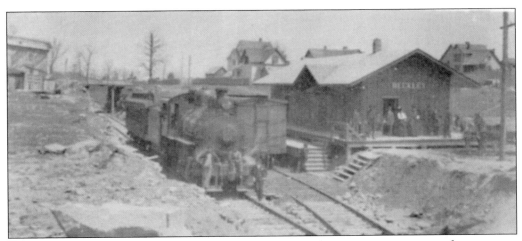

Once the railroad was built at the turn of the century, Beckley sprang to a position of importance that led to the immediate growth of Raleigh County and its becoming the Great Smokeless Coal Empire. Initially, wagons would meet the train and unload the freight. Passenger service provided easy access to town, which in turn increased business for mercantile establishments. Beckley Train Depot served until the 1960s, when freight began to arrive by truck, ending another era of transportation. The facility was destroyed by arson in 1992.

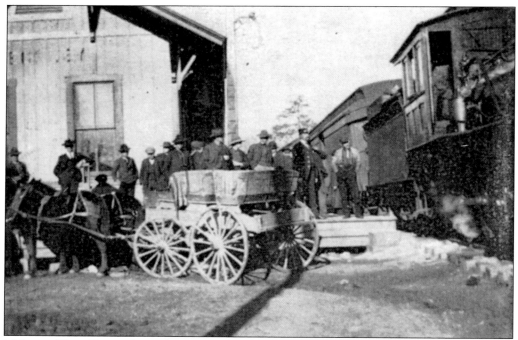

Mabscott Train Depot shows the wagons lined up to take freight off the railroad cars and make their daily deliveries in 1904. Families now had the opportunity to travel conveniently, making shopping, amusements, tending to legal matters, and reaching hospitals, doctors, and dentists far easier than ever before.

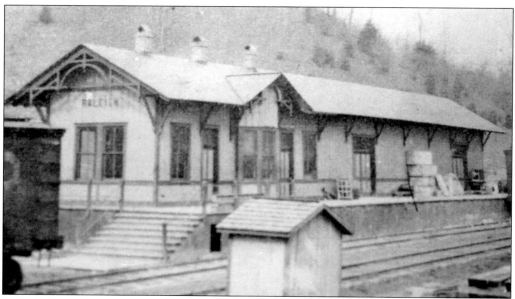

Raleigh Train Depot was a hub of activity at train time. The novelty of trains attracted many curious individuals and opened up a whole new world for people to receive goods, attend functions, and go places they had only heard and dreamed about. A new and exciting life had begun in the coalfields of West Virginia.

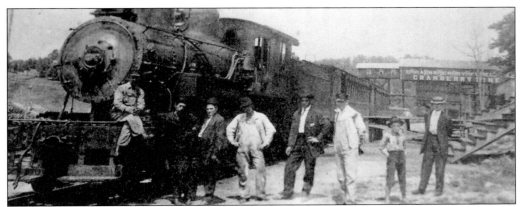

Passenger express coal rag "Old 299" at the Cranberry Mine made for a more bearable life for those living in small coal towns. "Old 299" made four stops a day at various locations, allowing people the opportunity to have a life beyond the coal camps, towns where everything was built, owned, and managed by a coal company. This included doctor's offices, churches, schools, stores, theaters, and residential structures. Prior to the trains, travel was limited to horse and wagon or your own two feet. On paydays, the trains were packed on each run.

Blue Jay Lumber sawed and shipped millions of board feet of southern West Virginia's timber across the country beginning in early 1900. The mill was owned and operated by P.C. Lynch, who operated one of the largest, most successful mills east of the Mississippi. There were many mills in the Beckley area at that time and every man who owned a stand of timber and could pay $1,500 bought a mill. Hardwood was plentiful here and in demand nationally and internationally. One could rightly say that much of America was built with West Virginia's lumber.

In 1902, this sidewinding shay ran from Glade Creek on New River to Beckley Seminary, providing direly needed transportation to connect coal mining and timbering towns. Coal mining and trains went hand-in-hand, and this holds true today. It was quite a task to build around these majestic mountains and deep valleys, but our forefathers just bit the bullet and got the job done. It was quite an amazing feat, considering men had to use tools constructed by their own hands, as the railroad companies did not provide tools of the trade.

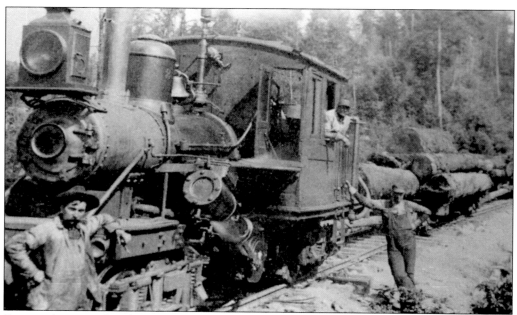

From timber to coal and passengers, railroads and trains were the most important transportation development man had experienced. As a new century began, a changing America emerged as these locomotives traveled across the country, opening new opportunities at every crossing as the Industrial Age arrived.

Three

PURSUIT OF THE AMERICAN DREAM

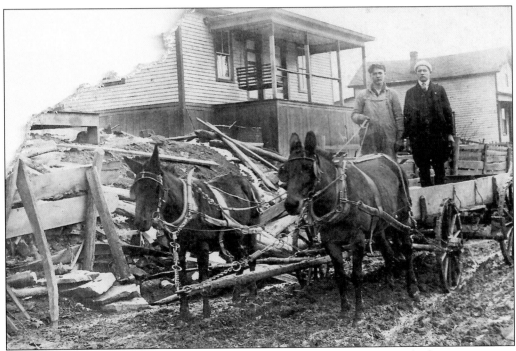

This photograph speaks volumes. Life was not easy in 1912, and everyone had to rise to meet the challenges of everyday living in the coal camps. Traveling through muddy alleys in what is said to be Sprague, these mules and unidentified men were not deterred from doing what needed to be done. Tenacity and hard work was the rule of the day. Times were tough and people were tougher. (Courtesy of RCHS.)

Abe Saks, an immigrant from Latvia, was born in 1895. In 1921, he came to Beckley and operated Abe's Army Store on Neville Street and later engaged in the jewelry business, opening Saks Jewelry Store. Abe was one of the 29 Jewish men who founded Temple Beth El in 1935. He died in 1947 while visiting relatives in Norfolk, Virginia.

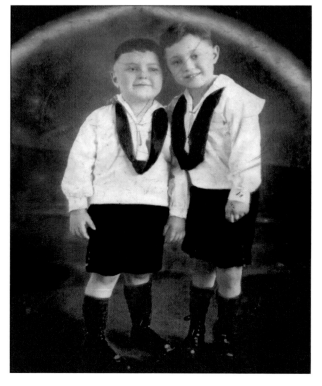

This photograph was taken in 1924. The two delightful children are Daniel and Bernard Saks, sons of Abe and Gussie Saks. Danny and Bernie became well-known and respected businessmen in Beckley, where they operated the family business, Saks Jewelry Store. The business, located at 314 Neville Street, closed in 1982. Another son, Robert, lived in Florida and was not affiliated with the business.

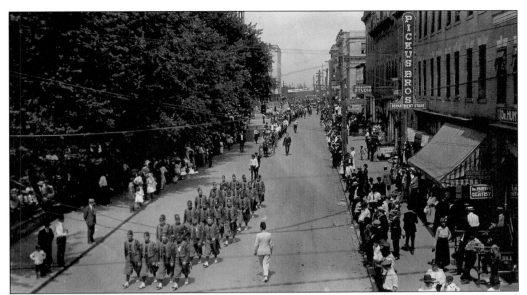

Raleigh countians loved a parade and came out in droves to watch the colorful marchers and enjoy the loud, wonderful music. This is thought to be the American Legion Parade around 1914, marching down Main Street. Parades offered a unique form of entertainment, and the streets were always lined with excited little faces. A century later, that has not changed. (Courtesy of RCHS.)

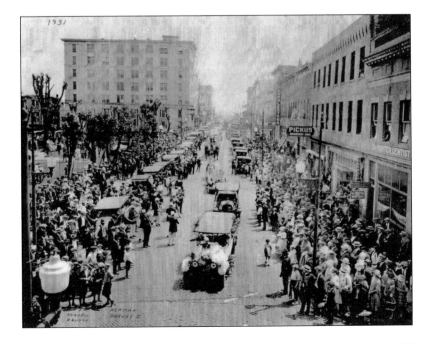

This 1931 parade was a big draw on Main Street. The two young boys standing at the bottom left are Vondell Holiday (left), whose head is turned, and Herman Harvey II. Automobiles were lined up in a parade, which was quite a novelty in those days, delighting everyone.

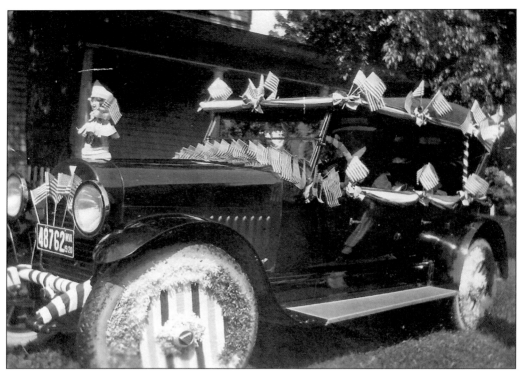

This patriotically decorated automobile is heading to a downtown parade. The year is unknown, but it is thought to be participating in a Fourth of July parade. Riding in an automobile during a parade was ultimate joy for any child lucky enough to do so. (Courtesy of RCHS.)

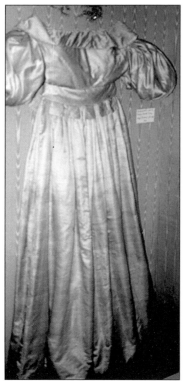

Alfred Beckley's bride, Amelia Neville Craig, wore this lovely wedding dress in 1832. It is on display in what was their home, Wildwood Museum.

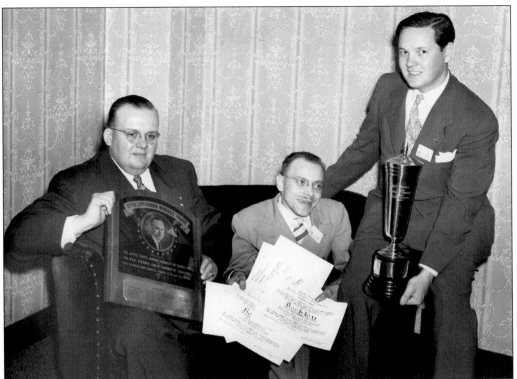

The Beckley Junior Chamber of Commerce won the coveted Giessenbier award on May 11, 1948. Warren Williams is holding the plaque, Virgil Miller is holding the award certificates presented at the state convention, and Hulett C. Smith is holding the trophy for their Christmas community lighting project. Smith was elected president of the West Virginia Junior Chamber of Commerce. (Courtesy of RCHS.)

This little charmer is five-year-old Clara Jane Ewart. The Ewart family was quite prominent in Beckley, dealing in cattle, farming, and leasing of coal properties. Ewart Avenue is named for this family, who lived on their many acres with spectacular views. (Courtesy of Katherine Williams.)

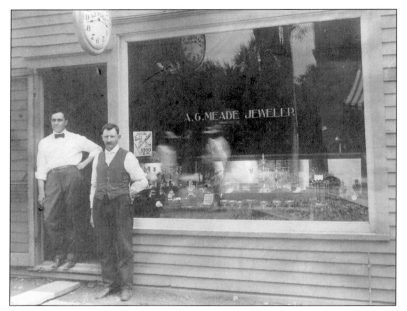

Jewelry businesses sprang up at the turn of the century and in 1908, A.G. Meade opened his store on Main Street, which later became the site of the E.M. Payne Company. Meade is pictured with P.W. McClung in front of his establishment. Many coal barons lived in the area, providing great clientele for merchants. (Courtesy of Russ Parsons.)

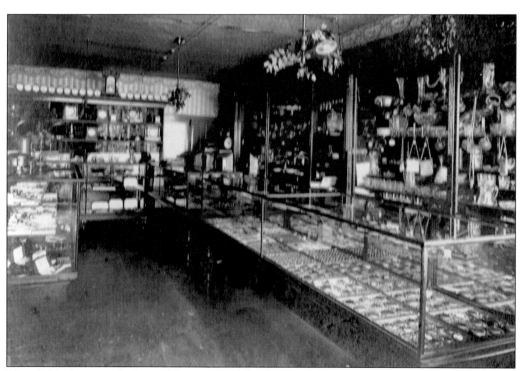

This 1908 photograph shows the interior of the A.G. Meade Jewelry Company on Main Street. The showcases tell their own stories, featuring elaborately decorated ladies' purses, crystal bowls, pitchers, goblets, silver pieces, and clocks, as well as fine jewelry. A beautiful array of high quality products was available to Beckley's wealthier clientele. (Courtesy of Russ Parsons.)

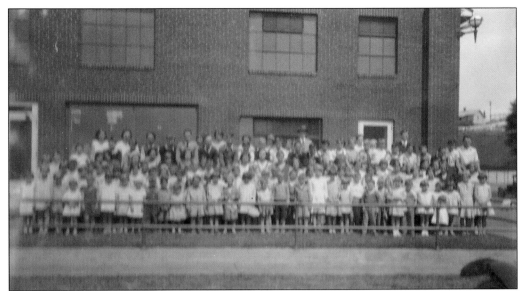

During the 1920s through the 1940s, Beckley Presbyterian Church conducted outreach Sunday school and vacation Bible school in the coal camps throughout Raleigh County. This class photograph was taken on the steps of the Cranberry Company Store. (Courtesy of Scott Worley.)

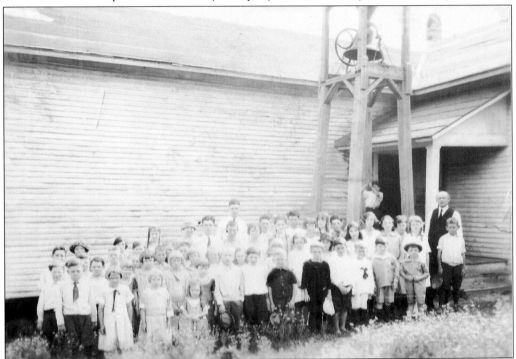

This photograph was taken at the Cranberry Grade School. Notice the bell overhead. These coal camp children were participating in the Beckley Presbyterian Vacation Bible School in the late 1920s, where they used the classrooms at the Cranberry school. The school building was razed around 1950 when the new Cranberry School opened. (Courtesy of Scott Worley.)

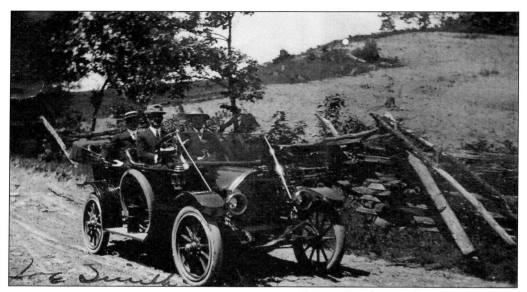

Harper Road was still unpaved when Joe Smith, Charles Proctor, and A.G. Meade toured the area in this early automobile that could only be driven in the dry weather months and was stored in a garage all winter. The horse-and-buggy era was fading quickly as these new pieces of machinery that demanded hard surfaces began taking to the roads. (Courtesy of Russ Parsons.)

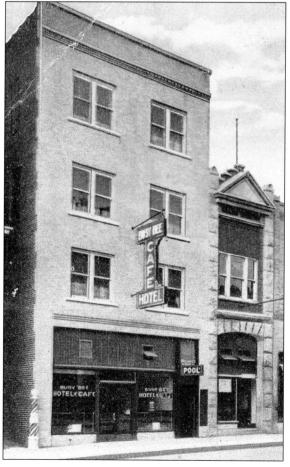

The Busy Bee Hotel and Café was located on Main Street beside the tiny *Raleigh Register* newspaper building in 1928. It appears that a pool hall was located underground. At one time, this was the location of Thompson Drug Company. (Courtesy of Russ Parsons.)

Tragedy struck the coalfields on December 17, 1940, when an explosion in the Raleigh Coal and Coke Company Mine at Raleigh killed eight men. Dr. M.C. Banks (lower right, wearing a hat) and Dr. C.A. Smith (left) rode out of the mine with the victims. Explosions and slate falls were no strangers to the mining communities, and the loss of a husband, father, friend, or brother in a coalmine accident was never far from the minds of coal mining families. (Courtesy of Scott Worley.)

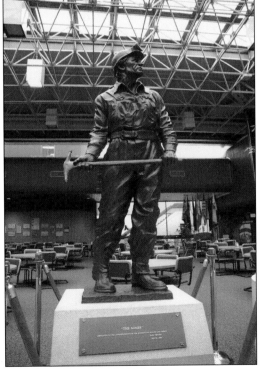

This bronze statue of a coal miner serves as a reminder of the hard work, dedication, and sacrifices made by coal miners who give of themselves each time they travel beneath the surface of the earth to extract the product that has provided power plants, steel industries, and numerous other endeavors that have made America the envy of the world. But it came with a very steep price. The statue stands inside the National Mine Safety and Health Academy. (Courtesy of MSHA Technical Services.)

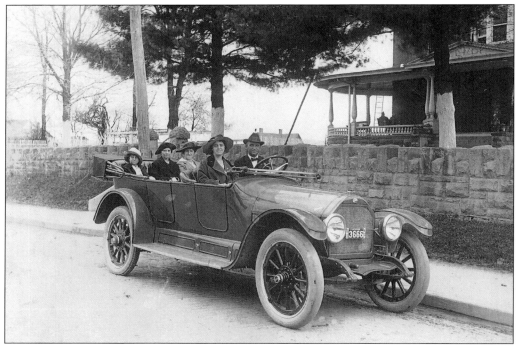

Dr. John Earl McCreery is pictured driving his new Overland with his sister Molly McCreery, niece Elizabeth Johnson, and friends Blanche Smith and Ad Williams in 1915. The vehicle price was $1,050 with no added taxes. At the time, no driver's license was required. The house on the right belonged to Sen. John McCreery and was located on South Kanawha Street where the former Appalachian Power Company, now Southern Communications, building stands. Senator McCreery is shown seated on the front porch swing. (Courtesy of Scott Worley.)

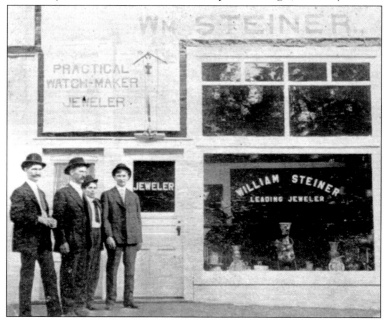

William Steiner Jewelers was located on Main Street in the early 1900s and was described as being the "Leading Jewelry Store of Raleigh County." With new money flowing from the black gold mining industry, jewelry was a profitable enterprise and Beckley had several family-owned jewelry stores that prospered as well. (Courtesy of Russ Parsons.)

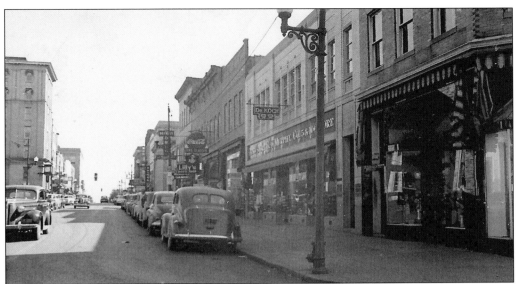

In this photograph is Beckley's busiest corner, Main and Heber Streets, as it appeared in 1942. Two-way traffic worked well with parking along the sides of the street, allowing quick and easy access to various shops. The buildings along Main Street had many owners, and numerous businesses have remained relatively unchanged. However, change has begun with the demolition of the G.C. Murphy block on Heber Street, where the new Judicial Annex is being constructed. (Courtesy of Joe Fourney.)

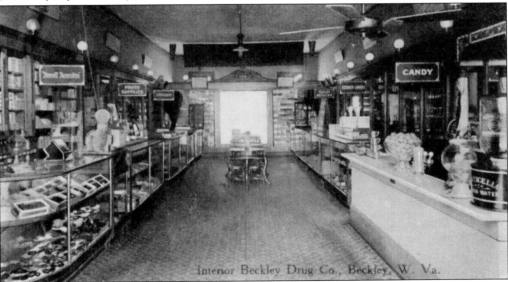

This photograph was taken inside Beckley's oldest store, Beckley Drug Store, located on Main Street, in 1915. It kept the same name from beginning to end, and remained in the same location until closing in the mid-1960s when "Doc" Bledsoe retired. When a former Beckleyan, C.B. Coburn, saw Beckley's richest relic being dismantled, he quickly plunked down hard cash and purchased every piece in the store. The huge, beautiful marble soda fountain with matching fixtures and prescription cases is the pinnacle of opulence that now graces Ghost Park in Maggie Valley near Ashville, North Carolina. (Courtesy of Russ Parsons.)

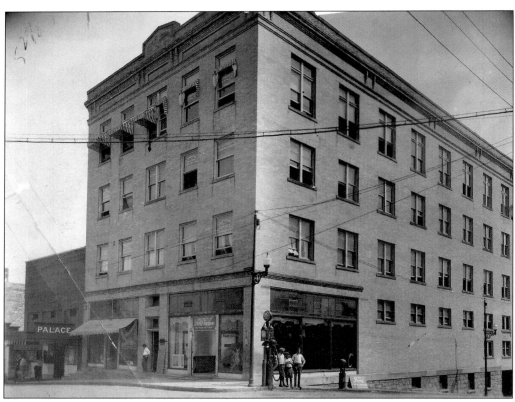

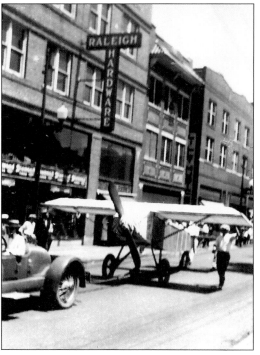

The occupant of the Bair Building on the corner of East Main and North Kanawha Streets was Ford-Fordson Sales and Service. Notice the gas pump on the corner. To the left sits the *Raleigh Herald* newspaper office and the Palace Theater, where coal camp kids piled in on Saturday afternoons to watch cowboy heroes and villains shoot their way across the prairies, all for 15¢. Leslie's Diner served the very best hot dogs around and stood beside the theater. The Palace building was razed in 2004 and is currently a parking lot. (Courtesy of RCHS.)

The sight of an airplane rolling along Neville Street deserved a second glance. Parades seem to bring out the best in people and creativity. Beckley certainly had its share of these attractions and even today, huge crowds come to town to enjoy parade festivities. (Courtesy of RCHS.)

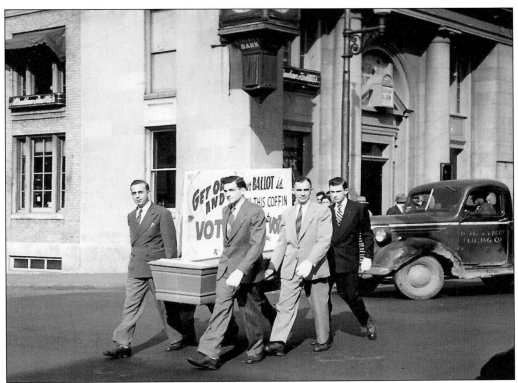

A very unexpected and unusual parade entry was this casket being carried by six pallbearers. These men apparently took the right to vote very seriously and certainly got their point across in a very determined manner. Patriotism was high on the list of priorities during the 1940s and 1950s, when World War II and the Korean War ended. The same men are pictured below on the steps of the Raleigh County Courthouse Their patriotic spirit was refreshing and their efforts surely brought more voters to the polls. (Both courtesy of RCHS.)

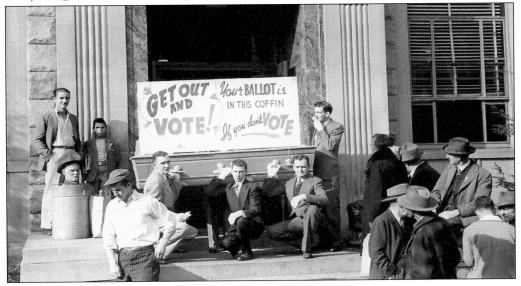

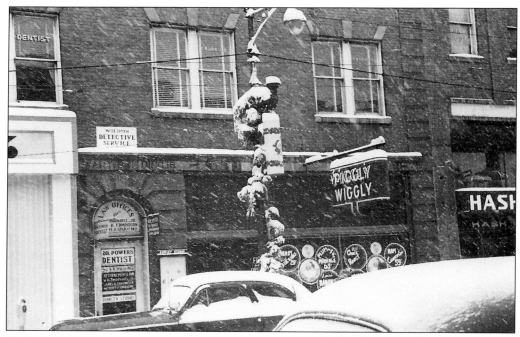

Piggly Wiggly, established in 1922, was located on Main Street near the Beckley Hotel and was the first self-service store in Beckley. This was of great benefit to the many immigrants who lived in Beckley and spoke little English. They could now select their groceries without having to point, explain, or pronounce the words for the clerks to fill their grocery list. (Courtesy of Joe Fourney.)

Dr. Grover C. Hedrick (left) and Dr. D.W. Snuffer are pictured with little Edd Karnes, who left Beckley to join a carnival as a snake trainer in the late 1930s. Edd's brother, Harry, was a schoolteacher of very large stature. Doctors Hedrick and Snuffer were longtime physicians in Beckley. (Courtesy of Russ Parsons.)

Rev. J.W. Dillon preached one Sunday each month at Mount Tabor Church from 1905 to 1906. He lived near Indian Mills in Summers County and to reach Mount Tabor, he had to walk 16 miles over the hills to Hinton, catch the C and O train to Prince, ride the Fanny to Cabell, and then walk half a mile to Mount Tabor. The round trip took four days. The church paid him $200 a year for his services even though he had no set fee. (Courtesy of Ann Underwood Mills.)

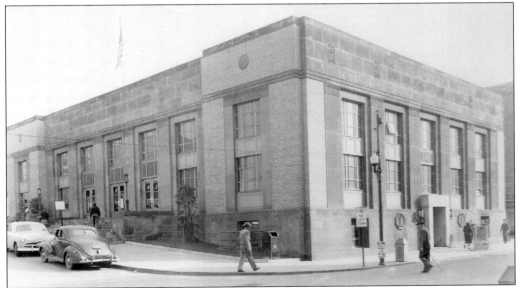

Beckley's first post office was established in 1853, when the town was called Raleigh Court House. This post office was built in 1932 and sat on the corner of Neville Street and Woodlawn Avenue. Patrons were served at this location until 1961, when the new building was constructed on North Kanawha Street. This building was then renovated and became the United States Federal Courthouse until the Robert C. Byrd Federal Courthouse Complex was completed in 1999. The two cars parked in front are a 1940 Ford and a 1950 Ford. (Courtesy of Pete Torrico.)

This charming Methodist Church stood on the corner of Heber and Earwood Streets in the 1800s. It was referred to as "Union" or "Mother Church" because it was a revered place for worship by six denominations in the late 1800s. As a lay preacher, Alfred Beckley preached sermons here from 1855 to the 1880s. The tiny church was razed in 1926. (Courtesy of RCHS.)

Charles Conner stands beside five bronze Civil War markers that were being dedicated on Veteran's Day in 1992. The Civil War sites were documented by Jody Mays and Jan Worthington. Charles was publisher of *The Register-Herald* and president of the Beckley Area Foundation, which provided the grant for the markers. (Courtesy of Dick Klaus.)

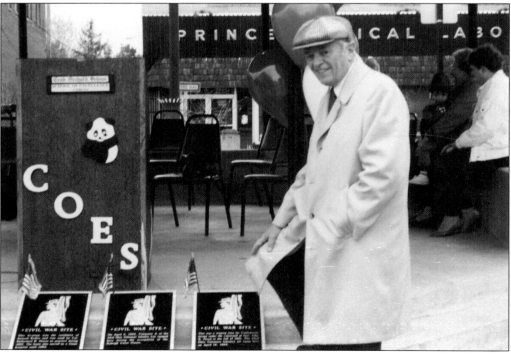

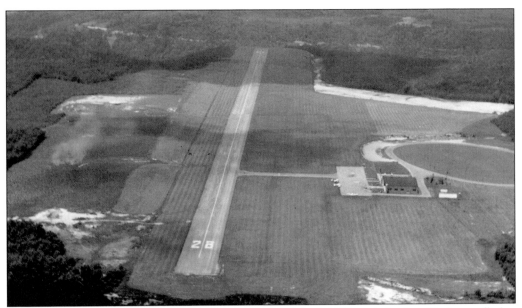

Raleigh County Memorial Airport was dedicated on July 4, 1952, and the first Piedmont flights began serving the new airport on July 15. The need for a longer runway soon emerged and a north-south runway of 6,000 to 8,000 feet was completed in 1978, making this the third longest runway in West Virginia. (Courtesy of RCHS.)

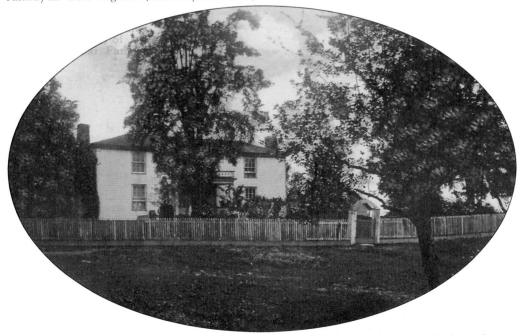

General Beckley's beloved home, Wildwood, was originally built as a double-wide log cabin on this site in 1835. The clapboard siding was added around the 1850s. The house now serves as Wildwood Museum, under the direction of Raleigh County Historical Society. (Courtesy of Scott Worley.)

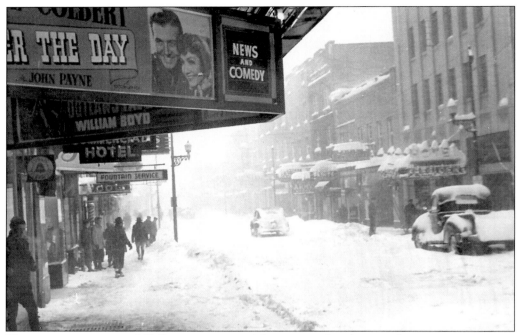

The spring snowstorm of 1942 was unexpected, but it gave the photographer an opportunity to capture this moment on Neville Street from the corner of Lyric Theater. Just like the snow, the businesses are gone, but beautiful memories of Beckley remain. World War II was being fought and a cloud of sadness hung over America. (Courtesy of Russ Parsons.)

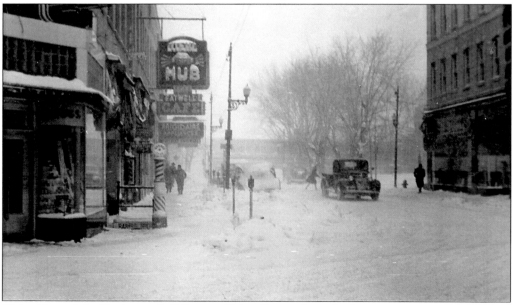

This old truck is slipping and sliding on Heber Street through the two-way streets downtown during the storm. No snowplows are at work yet. Notice the parking meters on the left near Watkins Drug Store, the Fink-Hub Department Store, McCormick Jewelry, Eatwell Café, and Beckley Hardware. (Courtesy of Russ Parsons.)

Four

EDUCATION AND
EDUCATORS

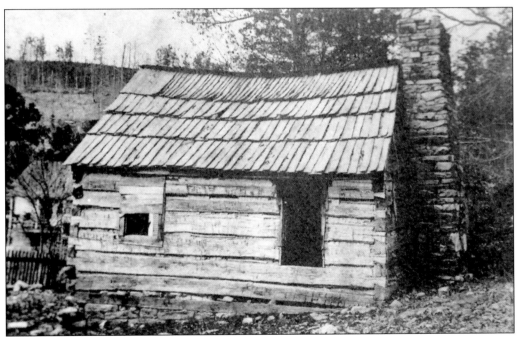

This tiny log school in Lester was mortared together in 1867 and stood near the former Virginia Railroad Station. This small one-room structure produced some mighty minds. John Q. Hutchinson began his schooling here, taught by Sarah Bryson. Hutchinson became an attorney and a senator. The Bryson name remains prominent in education even today, as we recall D.W. Bryson, who served as superintendent of Raleigh County schools from 1945 to 1957.

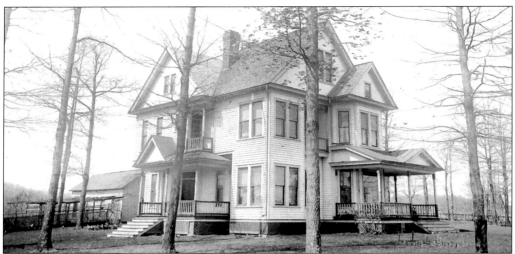

Prof. Bernard H. White is often referred to as the father of education in Raleigh County. With his own hands, White built Beckley Seminary in 1900, making it the first four-year high school in the county. It was tuition supported. Subjects taught were natural sciences, preparatory classes, shorthand and touch writing, commercial and penmanship, and music. The school operated until 1907, when it was sold and the name was changed to the Beckley Institute.

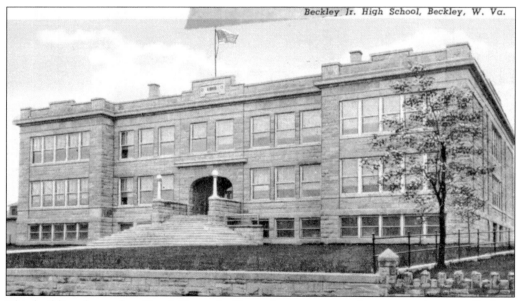

This building, located on South Kanawha Street, has seen many changes in education. Built in 1918, it was opened as a public high school, establishing a six-year high school. By 1925, a larger facility was needed and this building then became Beckley Junior High School. A new school was built in Gray Flats, combining Beckley Junior High and Stratton Junior High into the new Beckley-Stratton Junior High. This building, sold to Mountain State University, was remodeled, and is once again a lovely educational facility, having gone from high school to junior high school and now to university. (Courtesy of Emmett S. Pugh.)

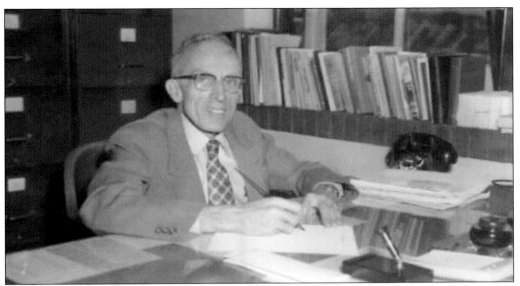

Clarence Gilbert Peregoy served as principal of Woodrow Wilson High School from 1933 to 1963. His manner of conducting the school's operation made it one of the first-class schools in West Virginia. Peregoy earned the respect and admiration of faculty and students and was well-known in state and national education organizations. This photograph was taken in 1958. He died at age 93 in 1993. (Courtesy of Phyllis Peregoy Payne.)

Woodrow Wilson High School opened in 1925. Part of the building was used by Beckley Institute Elementary School until 1935. WWHS was outstanding in academics, having produced thousands of highly successful citizens. Those who were fortunate enough to have Jean Porter for English were definitely among the high achievers. She taught her students to use their own minds and think for themselves. Educators of decades past were not bound by federal regulations. The Board of Education was in charge of teaching methods and produced great educators, who in turn produced great students. (Courtesy of Emmett S. Pugh.)

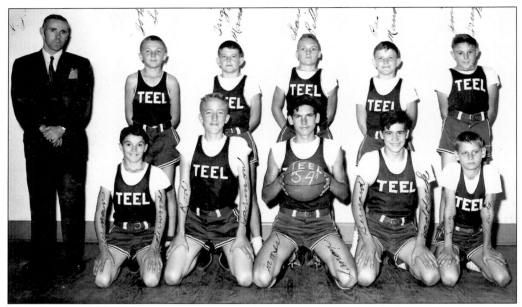

This photograph shows Teel Elementary School's basketball team from the 1953–1954 school year. The coach, I.J. Martin, also taught seventh grade. The players are, from left to right, (first row) Norman Underwood, Rodney Harmon, James Lomax, Bernard Haddix, and Ray Lewis; (second row) John Sotak, James "Trigger" Mandeville, Charles Pittman, John "Pee Wee" Mandeville, and Jimmy Fruggie.

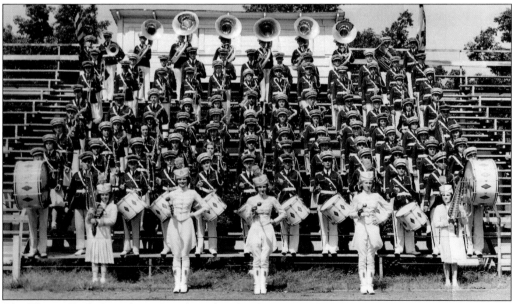

The Flying Eagle Marching Band, under the direction of Glenn Sallack, was pure precision perfection. This 1940 photograph represents thousands of students who learned dedication, discipline, music appreciation, and respect, as well as garnering a bonding experience that endured a lifetime. Learning to play an instrument was taught in a class, but the side benefits of being in Sallack's band were priceless. (Courtesy of Russ Parsons.)

Form 11-A Duplicate—20M-4-40

STATE OF WEST VIRGINIA,
DEPARTMENT OF EDUCATION:

TEACHER'S CONTINUING CONTRACT OF EMPLOYMENT

THIS CONTINUING CONTRACT OF EMPLOYMENT, made and entered into the **FIRST** day

of **JULY**, 19**40**, by and between THE BOARD OF EDUCATION OF THE COUNTY

OF **RALEIGH**, State of West Virginia, party of the first part, and

_____,

(Name of Teacher)

of **PLUTO RALEIGH WEST VIRGINIA**, a teacher holding a **STANDARD NORMAL**
 (Post Office) (County) (State) (Kind of Certificate)

teacher's certificate issued under the laws of the State of West Virginia, and now in force, party of the second part:

WHEREAS, at a lawful meeting of the Board of Education of the said county of **RALEIGH**,

held at **BECKLEY**, on the **FIRST** day of **JULY**, 19**40**,

the party of the second part was duly appointed for continuing employment as **TEACHER** in the

public schools of said **RALEIGH** County, at a salary for the school term beginning on the **THIRD**

day of **SEPTEMBER**, 19**40**, of **ONE HUNDRED SEVEN AND 50/100** (**$07.50**)

per month, salaries for subsequent school terms to be fixed as hereinafter set forth, and the party of the second part
has accepted said appointment; and

WHEREAS, Section 1, Article 7, Chapter 18 of the Code of West Virginia, as last amended, provides, among
other things, that before entering upon their duties all teachers shall execute a contract with their boards of education,
in the form prescribed by the state superintendent of schools, and that every such contract shall be signed by the
teacher and by the president and secretary of the board of education; and

WHEREAS, this contract is in the form prescribed by the state superintendent of schools:

NOW, THEREFORE, THIS CONTRACT WITNESSETH:

That pursuant to said appointment and in consideration of the said monthly salary to be paid for the said
school term in the manner and at the times prescribed by law, and of the monthly salary for any and all subsequent
school terms to be fixed by the party of the first part according to law and to be paid in the manner and at the times
prescribed by law, the party of the second part agrees faithfully to perform all the duties of said position and employ-
ment, and agrees faithfully to observe and enforce the rules and regulations lawfully prescribed by legally consti-
tuted school authorities in so far as such rules and regulations may be applicable to said county.

THE PARTIES HERETO MUTUALLY AGREE:

(a) That the services to be performed hereunder by the party of the second part are to commence on

THIRD day of **SEPTEMBER**, 19**40**, and are to be performed in such school or schools, and

at such place or places as may be designated by the party of the first part.

This teacher's continuing contract of employment dates to July 1, 1940, and is a good example that
teachers have always been underpaid. This teacher was only paid $107.50 per month. (Courtesy
of Fran Klaus.)

These 1954 kinder grads were students of Mrs. Nettie Edwards, who taught from her home at 301 North Kanawha Street. The students are, from left to right, (first row) Ellen Dillon, Gary Wein, Nancy Vines, Al Lovitz, Margaret Thorne, Joe Luchini, Betsy Brown, Peggy Brown, and Bill DePaulo; (second row) Bobby Primas, Freddie Mason, Tommy Ray Mullens, Raymond Meyers, Linda Honaker, Tim Trimmel, Alex Johnson, Pamela Cook, R.T. Bair, Alicia Fragile, Rusty Parsons, and Hal Lynn Scott. (Courtesy of Russ Parsons.)

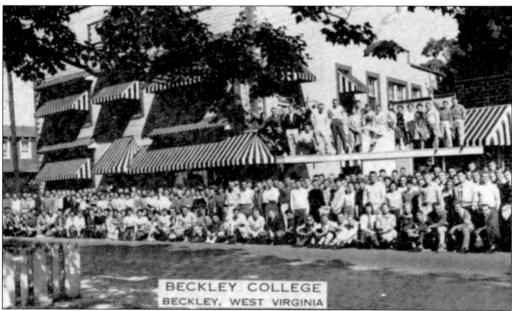

This 1958 photograph shows Beckley College, West Virginia's largest junior college and only community college. It got its start in 1933 under the management of D.K. "Ken" Shroyer in the basement of a local church with just a handful of students. This modest beginning has led to it becoming the College of West Virginia in 1991, just one year after Dr. Charles H. Polk became its sixth president. In 2001, it became Mountain State University. (Courtesy of Russ Parsons.)

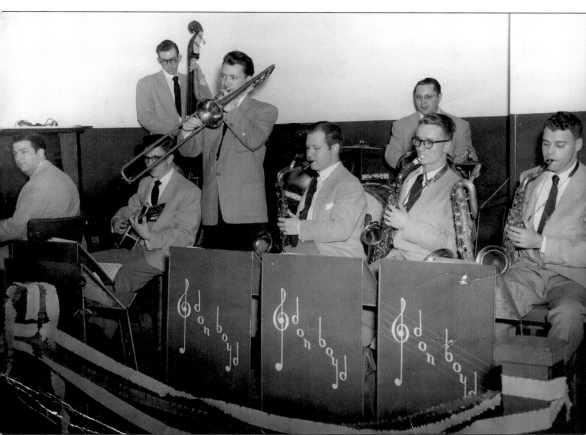

Don Boyd was one of the finest musicians Beckley has produced. Don was a student of Glenn Sallack's Flying Eagle Band and continued his musical career playing the trombone during the big band era with Harry James, Glen Gray, and Les Brown. He brought his talents to Beckley and formed his own band, called the Don Boyd Orchestra, where he continued his career from the late 1940s to 1970s. Shown here are: Don Boyd (trombone), Harold Miller (saxophone), Ray Harper (saxophone), Ray Light (trombone), J.W. Muir (piano), Tommy Dickenson (bass), Jimmy Fleshman (guitar), and Bernie Saks (drums). Don's wife Betty was the lone female vocalist with the group. The Boyds moved to South Carolina in the late 1970s, where they continued performing.

This view of Sandstone Falls has been photographed more times than one can count. These magnificent, picturesque falls were as treacherous as they were beautiful and navigable only at high water. Chief Justice John Marshall suggested that a dam and lock be built to enable navigation in 1812. (Courtesy of National Park Service.)

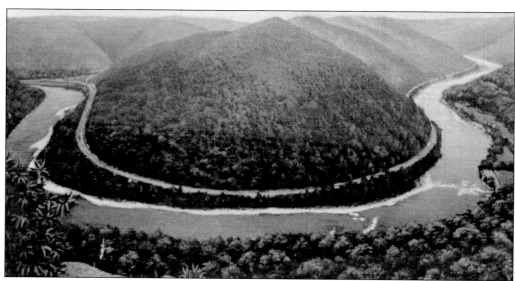

Grandview certainly lives up to its name and is a photographer's dream. The park covers 878 acres and has an elevation of 2,430 to 2,555 feet. It offers spectacular views of the New River Canyon, enormous, unique rock formations, numerous picnic areas, caves waiting to be explored, hiking trails, and rock climbing, and is home to Cliffside Amphitheater. Located at Grandview, it is a 10-minute drive from Beckley off I-64 East. (Courtesy of RCHS.)

Five

A City With a "Mine" of Its Own

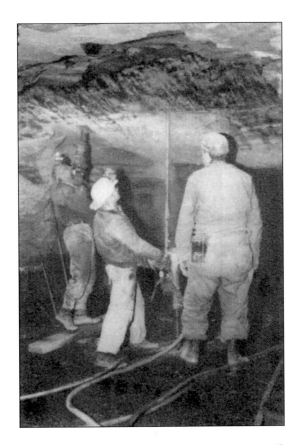

Few Americans possess even superficial knowledge of coal-mining methods or the way of life and death of the men who, in the past, brought to the surface the fuel that heated homes and powered factories. The Beckley Exhibition Mine opened to the public in June 1962 and has become a destination for up to 50,000 visitors annually. A six-ton mine motor pulls carloads of visitors on steel rails over 1,500 feet through connected rooms by "breakthroughs," offering a first-hand experience of early coal mining. Exhibits include old mining equipment and coal being hand-loaded by miners and hauled out by mules. The mine is listed in the National Register of Historic Places. (Courtesy of Renda Morris.)

The Best of West Virginia is the nation's first showcase of handcrafts, fine art, and regional cuisine. Tamarack opened its doors in 1996 and has been selling handcrafted merchandise from artisans in all 55 West Virginia counties. It features working studios for resident artisans, a fine art gallery, a theater, and a Taste of West Virginia food court, managed by the Greenbrier Resort.

The National Mine Academy, located in Beckley near the Raleigh County Airport, is one of the eight federal academies responsible for training mine safety and health inspectors and for technical support of the Mine Health Safety Academy. Beckley's facility accommodates 600 students and consists of nine buildings, seven of which are adjoining. The academy opened its doors in 1976 on the 76 acres of land donated by the Raleigh County Airport Authority. (Courtesy of MSHA Technical Service.)

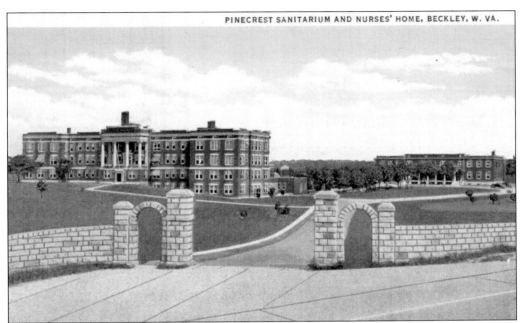

Pinecrest Sanitarium was authorized by an act of the 1927 legislature and opened on March 18, 1930. Initially, it was called Rutherford Sanitarium and it treated patients afflicted with tuberculosis, but the 1934 legislature changed the name to Pinecrest Sanitarium. In 2010, the name was changed again to Jackie Withrow Hospital. (Courtesy of Emmett S. Pugh.)

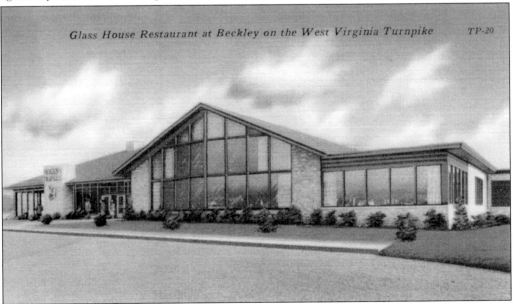

Glass House Restaurant at Beckley on the West Virginia Turnpike TP-20

The Glass House opened on November 8, 1954, and was located just north of the Beckley interchange on the West Virginia Turnpike. The $113,000,000 turnpike opened on this date and the media swarmed Beckley. The Glass House became a top-notch dining destination for locals and was a successful tourist attraction. The landmark closed on March 15, 1993. (Courtesy of Emmett S. Pugh.)

This 1964 photograph of a Wilkes Distributing truck is a flashback to the days when delivery trucks ran on six wheels, not 18. (Courtesy of Betty Wilkes.)

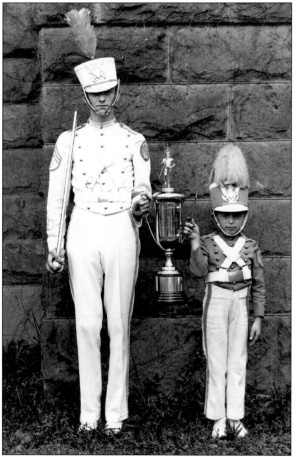

Russ Parsons Sr. was a drum major in the American Legion Convention's big Chicago parade in 1940. He is shown displaying his first place trophy. The little fellow is unknown. Russ sold and serviced Studebaker automobiles on First Avenue until Studebaker ceased business in 1960. (Courtesy of Russ Parsons.)

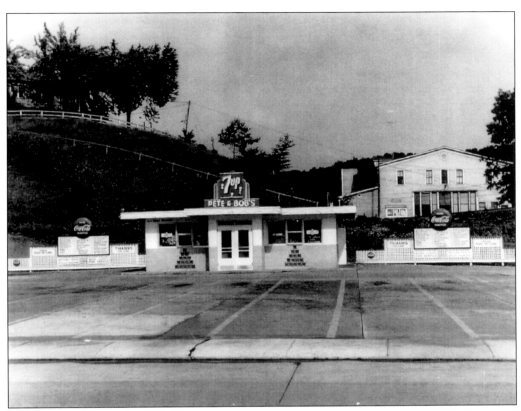

In 1952, Pete & Bob's Drive-In Restaurant opened on Valley Drive, now Robert Byrd Drive where Captain D's Seafood currently sits. Every teen who had access to wheels would surely be at Pete & Bob's on Friday and Saturday nights with friends piled in, hanging out the windows. If you were Catholic, those hot dogs and hamburgers never smelled better than on a Friday night. Curfew was 11:00 p.m. for most teens and that was acceptable. Be seen, have fun, eat, and go home. Pete George and Bob Long operated this icon until 1979. Bob Long is shown at right standing beside their mascot, Pebo. Note the Sprague Company Store at the upper right of the above photograph.

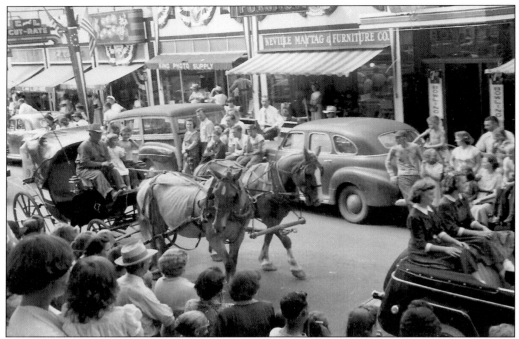

Raleigh County was sliced from Fayette County on January 23, 1850, when the General Assembly met at Richmond and approved an act for the formation of a new county west of the Blue Ridge Mountains. One hundred years later, Beckley celebrated from August 27 through September 2 with parades, contests, stories, and genuine fun. The children in the horse-drawn buggy are Vee and Meade Parsons. (Courtesy of Russ Parsons.)

Construction of the YMCA on Prince Street was just getting underway when this photograph was taken on March 31, 1978. The YMCA was previously located in the Soldier's and Sailor's Memorial Building on South Kanawha Street. (Courtesy of Dick Klaus.)

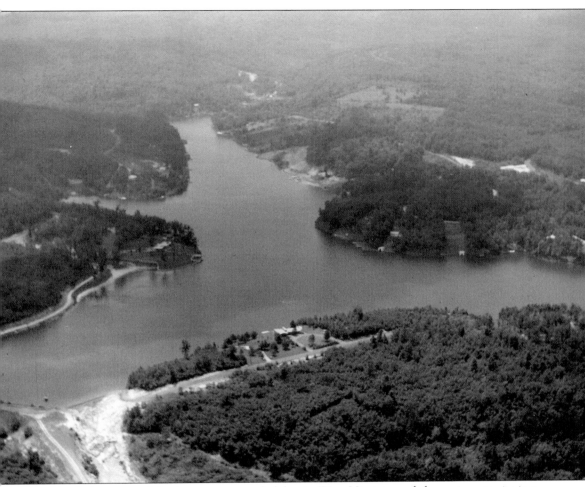

Flat Top Lake is one of the largest man-made lakes in West Virginia and the main gate sits just 15 miles south of Beckley. The site consists of 2,200 acres of land. The lake itself consists of 230 acres of water, has an eight-mile-long shoreline, contains 1,300,000,000 gallons of water, and is 30 feet deep. The entire project took only 105 days to build and was completed in 1950 at the cost of $350,000. Initially, 55 permanent homes were established and currently 269 homes surround the lake.

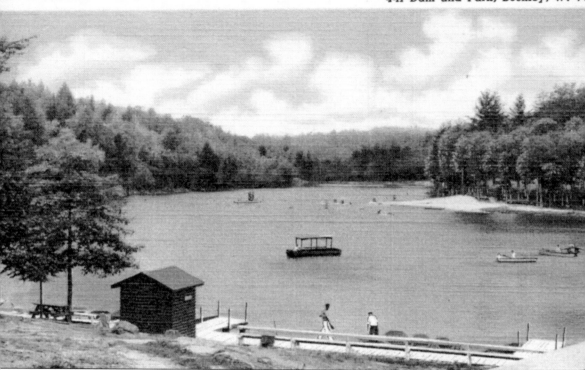

Little Beaver Lake, sometimes called 4-H Lake, opened in 1941. It was a wonderful place for swimming before it closed in 1966. At the time, housing developments were established near the runoff areas and the health authorities declared it a health hazard. It is now used for paddle boating, picnicking, hiking, camping, nature studies, and fishing. During the 1950s, the pavilion was filled with teenagers every Friday and Saturday night, jitterbugging at the Record Hop. (Courtesy of Emmett S. Pugh.)

Honey in the Rock, one of the longest running outdoor musical dramas in the United States, is a historical epic that describes how West Virginia was born out of the anguish of the Civil War. It made its debut on June 25, 1961. The name comes from the Native Americans' description of the strange natural gas wells they discovered when they first settled the area. The perfectly designed Cliffside Amphitheater in Grandview has provided over a million visitors with the excitement of outdoor musical drama. (Courtesy of Theater West Virginia.)

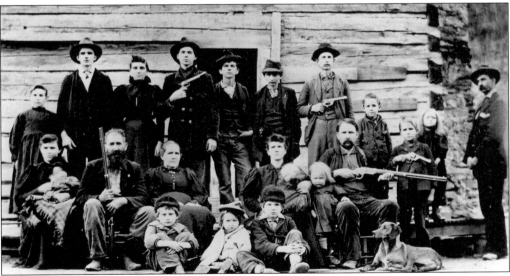

Hatfields and McCoys opened in 1970, joining *Honey in the Rock* as Theater West Virginia's second drama. The Hatfields settled on the eastern side of the Tug River in West Virginia and the McCoys moved on into the wilds of eastern Kentucky. During the Civil War, the Hatfields aligned with the Confederate states while the McCoys remained with the Union. Rand'l McCoy and "Devil" Anse Hatfield riled against one another for generations. This photograph of the Hatfield family was taken at a logging camp in Logan County around 1896. (Courtesy of Theater West Virginia.)

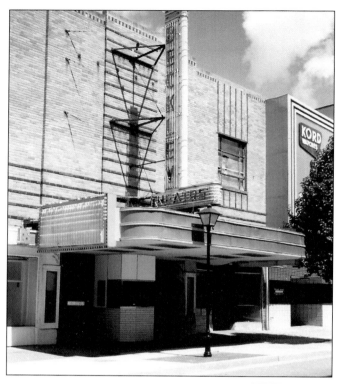

Beckley Theater stood on Neville Street, flanked by Ramey's Sweet Shoppe and Berman's Jewelry from 1935 to 1997, when it was razed by the city. The building had sat vacant since 1982. The site became a parking lot for 60 vehicles. The white marble that surrounded the immense interior lobby was magnificent. Lines of eager patrons stretched down Neville Street as the Marquee brightly beckoned the moviegoers. Now the lights have vanished, leaving only wonderful memories of a bygone era. Ironically, the sites of all three former theaters, Palace, Lyric, and Beckley, are now parking lots.

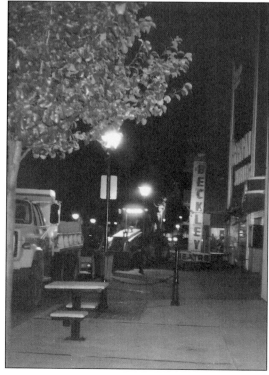

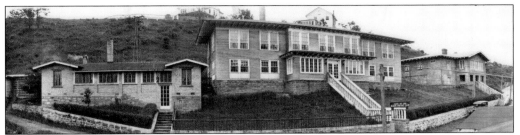

This building is located at Raleigh, just over the hill from Black Knight Country Club. It is said that Black Knight actually got its start from this building as coal barons discussed the need for a grand facility in Beckley. (Courtesy of George Bragg Collection.)

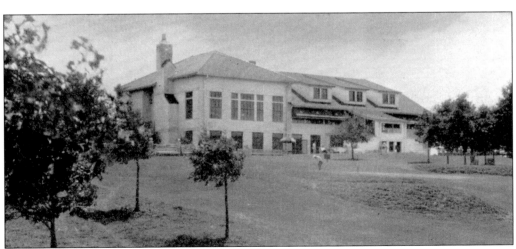

Black Knight Country Club built the existing structure in 1929. This view is from the 9th hole. Black Knight hosted thousands of functions over the past 81 years and, like many country clubs across America, fell on hard times and was sold in June 2011 to Jim Justice, the new owner of the famous Greenbrier Resort and Glade Springs Resort. Perhaps the best is yet to come. (Courtesy of Russ Parsons.)

The 9-Hole golfers at the Black Knight Country Club enjoy their annual awards celebration in 1981. The golfers are, from left to right, (first row) Barbara Gardener, Fran Klaus, JoAnn Byron, Betty Bowers, Iris Reardon, and Ruth Parsons; (second row) Chris Lilly, Rosie Gates, Fanna Lee Burns, Betty McLean, Hester Thacker, Margaret Sayre, Carolyn Clark, and Theresa Edwards; (third row) Lois McLean, Betty Daniel, Gerry Sigmund, Katherine Williams, unidentified, Pat Earehart, and Virginia Pugh. (Courtesy of Sherry Ambrosiani.)

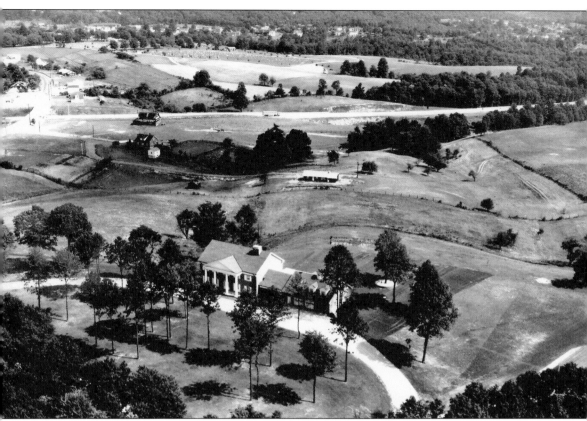

This view of Interstates 64 and 77 was taken from the air above Gov. Hulett C. Smith's home on Harper Road when the two roads were completed in 1988. Interstate 64 travelers can now drive from the east coast to the west coast without leaving an interstate highway. Interstate 77 takes north to south travelers from Maine to Florida. (Courtesy of RCHS.)

Who would have thought these two brothers would one day become our leaders. Joe L. Smith Jr. opened Beckley's first radio station, WJLS, in 1939. His younger brother Hulett C. Smith served as West Virginia's governor from 1965 to 1969. (Courtesy of RCHS.)

Beckley Hospital was opened in 1913 by Dr. J.E. Coleman and Dr. Robert Wriston. In 1921, Dr. A.U. Tieche came to Beckley from Winding Gulf and acquired all assets of the hospital with his partner, Dr. J.H. McCulloch. It closed in 1997. (Courtesy of Russ Parsons.)

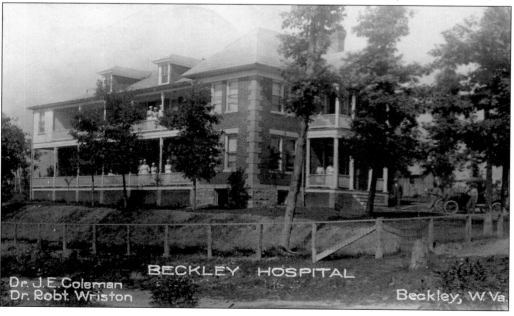

Dr. J.E.Coleman
Dr. Robt. Wriston

BECKLEY HOSPITAL

Beckley, W.Va.

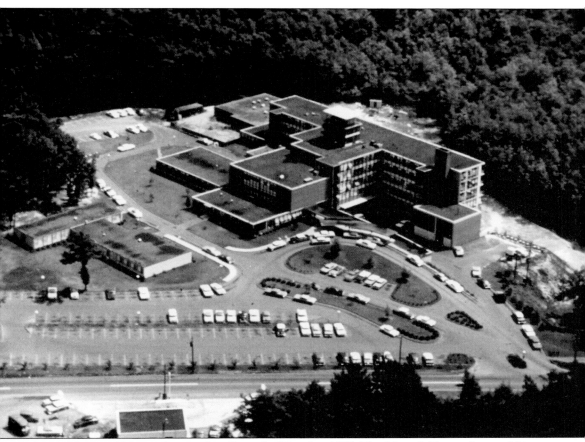

Miner's Memorial Hospital opened on Stanaford Road in 1956. The Miner's Hospital was sold in 1994 and the name was changed to Beckley Appalachian Regional Hospital. The area's medical facilities have grown extensively and Beckley has become the medical center of southern West Virginia. This view of the Miner's Hospital was taken shortly after its opening in 1956.

To create the municipal parking lot that included 320 parking stalls, 55,000 cubic yards of fill was used. The cost for the project was $550,000, and it began in 1953 was completed in 1954. On December 13, 1994, Beckley Common Council agreed to sell the municipal parking lot to the federal government for $1,725,000 to build a $40,000,000 federal complex and courthouse. This measure sent everyone who worked or shopped downtown into a frenzy trying to find a place to park. Ironically, the relatively new parking building that was located on Prince and East Main Streets was condemned and razed in 1994, leaving downtown without a municipal parking lot.

Once again in 1995, a gigantic hole appeared in the former municipal lot while construction began on the federal complex and was completed in 1999. Two holes in one!

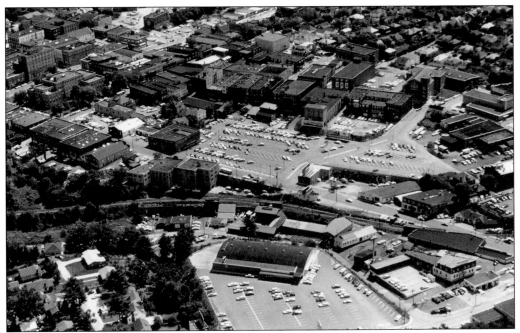

This photograph shows Beckley in 1954. The 1950s were tumultuous times for Beckley and Raleigh County, as coal production dropped dramatically and unemployment rose just as dramatically. From 1950 to 1960, Raleigh County's population dropped from 96,273 to 77,826, and Beckley's population dropped from 19,397 to 18,462. In the 1970s, interstate highways were being built, creating easy access for travelers and industry. This gave Beckley the opportunity to reinvent itself.

Jan Campbell Music Company operated on Main Street from the 1960s to the 1980s. It's where pianos and other musical instruments were sold, and music lessons were taught by Don Boyd. Radio station WCIR operated from the second floor. The building is currently occupied by Brown Reporting Agency. (Courtesy of Raleigh County Public Library.)

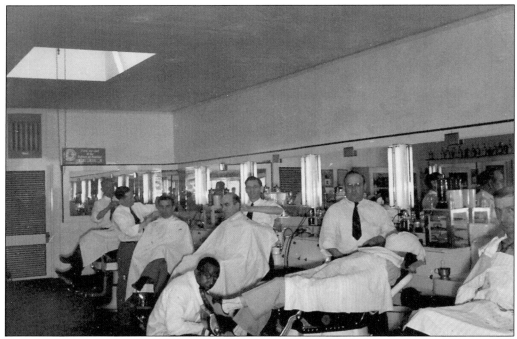

Shave and a haircut, two bits. Well, maybe a bit more in 1942, but the professional barbers located downstairs in the Beckley Hotel were always in demand. The barber pictured at the far left is Tom Rose, who owned the shop with Wade and Kirby Surbaugh until 1950, when he and Cecil Sherkey bought out the Surbaughs. In 1958, Rose bought Sherkey's share for full ownership. The man shining shoes is Wilfred L. Jeffries, who operated Jeffries Hat Cleaner and Shoe Shine. (Courtesy of Joe Fourney.)

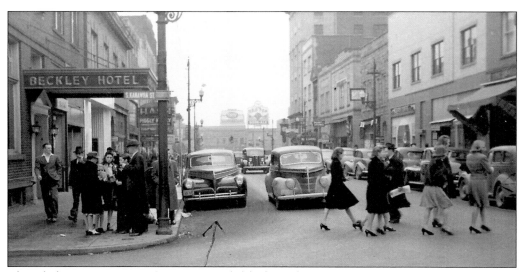

These ladies crossing Main Street were stylishly dressed in 1942. Streets were filled with shoppers from Monday through Saturday, but never on Sunday. (Courtesy of Russ Parsons.)

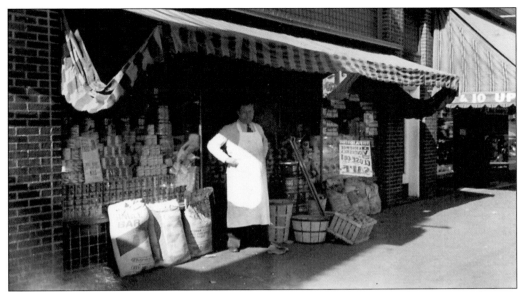

This butcher standing in front of Mick or Mack Groceries and Meats on Main Street is indicative of food markets through the late 1940s. Meat was cut to order and with the bus station around the corner, customers could buy fresh meat for less than purchasing from the company store and get it home quickly. Having meat for supper was a luxury for many families and there were no freezers at the time. Meat was generally prepared for the family's Sunday supper. (Courtesy of Joe Fourney.)

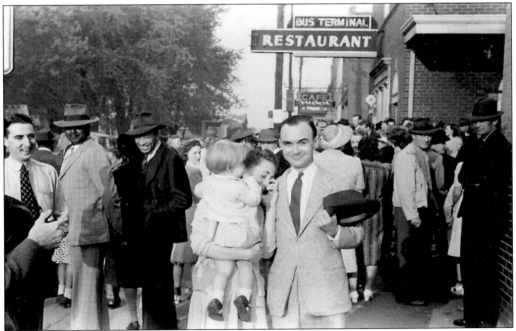

The crowd at the bus terminal on Prince Street is awaiting the arrival of actress Greer Garson, who was touring the country in 1942, promoting the sale of United States Savings Bonds, sometimes referred to as war bonds. (Courtesy of Joe Fourney.)

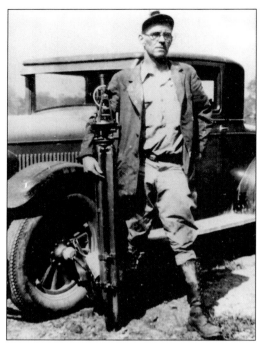

William Anderson Curtis served as Raleigh County surveyor in the 1940s and 1950s. He is shown at left with his Model A and his transit in the 1930s. Pictured below in 1935 is the Curtis family at 101 Johnstown Road in Beckley. They are, from left to right, (first row) Lizzie Belle (wife), Dick, Hattie (mother), William, and Grace; (second row) sons Herbert, Wirt, Homer, and William. The man seated on the far left of the porch is A.J. O'Neal. (Courtesy of Connie Curtis Snuffer.)

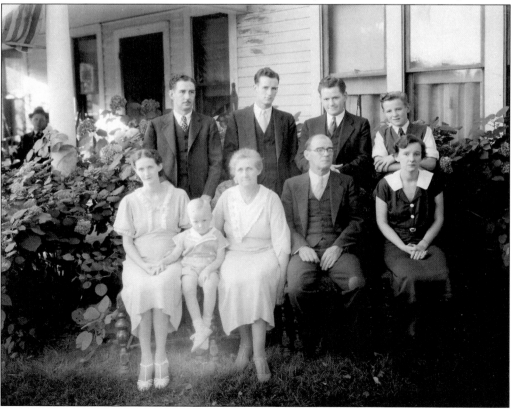

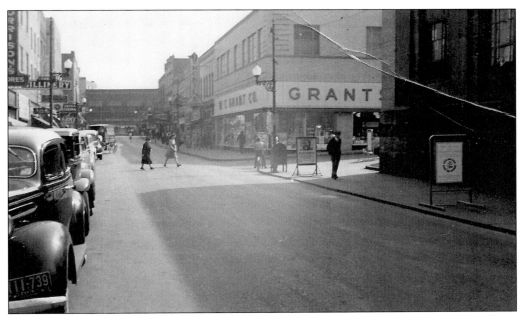

This 1942 scene of Neville Street shows the W.T. Grant Company on the corner of Woodlawn Avenue. Grant's was one of the busiest stores in Beckley, offering clothing, housewares, toys, candy, school supplies, and fish tanks that mesmerized children. (Courtesy of Joe Fourney.)

Patricia Searle owned The Purple Box during the 1950s and 1960s. This dress shop was located in the Raleigh County National Bank building, now United Bank, and offered unique styles and accessories for Beckley's stylish ladies. (Courtesy of Raleigh County Public Library.)

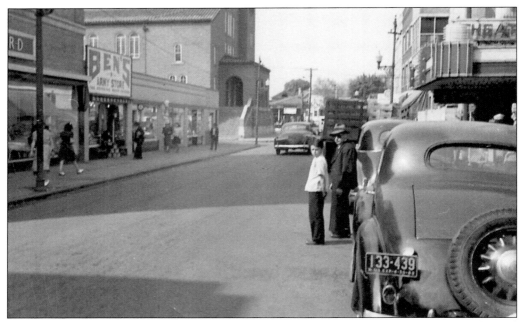

Another view of Neville Street in 1942 shows Beckley Theater's marquee on the right and Montgomery Ward and Ben's Army Store on the left. All of these stores are out of business, but the First Baptist Church is one of the few landmarks remaining in downtown Beckley. (Courtesy of Joe Fourney.)

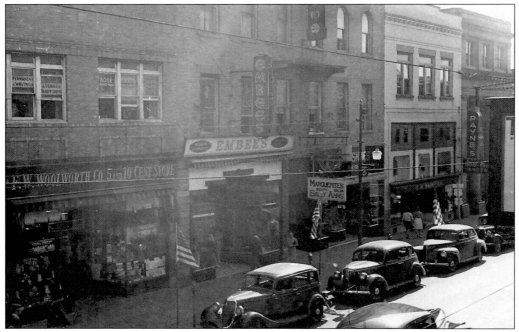

In the 1940s, Main Street was filled with a variety of retail stores. In this photograph are F.W. Woolworth Co. 5 and 10 Cent Store, Embee's Dress Shop, Marguarite's Hair Salon (on the second floor), Schiff Shoes, and E.M. Payne Company. (Courtesy of Joe Fourney.)

A driver's view of the corner of Main and North Kanawha Streets in 1941 shows White Cross Pharmacy in the Bair Building. To the left on Main Street is Boston Candy Kitchen, which became the Kozy Korner that was embraced by every teenager in Beckley in the 1950s. (Courtesy of Joe Fourney.)

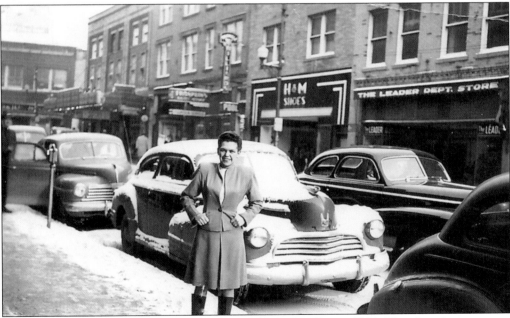

Gussie Saks stands on Neville Street in front of Saks Jewelers in 1940. That location was soon outgrown and they moved across the street to 314 Neville Street, where Lost Parrot currently sits. Beside the Leader Department Store is H&M Shoes. When the Lyric Theater closed in 1959, H&M remodeled the building and moved up the street. (Courtesy of Dick Klaus.)

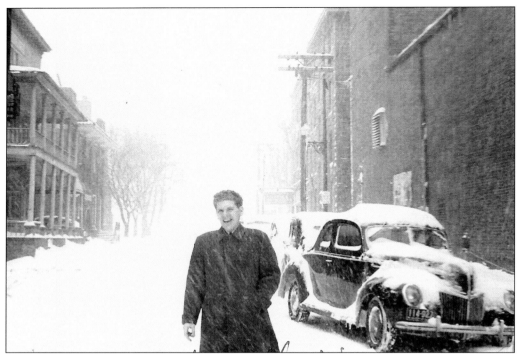

Bill McCormick trudges through the snow on Heber Street in January 1942. Notice the Willis Hotel on the left. All the buildings in this picture are now gone and the sites have become parking lots. (Courtesy of Russ Parsons.)

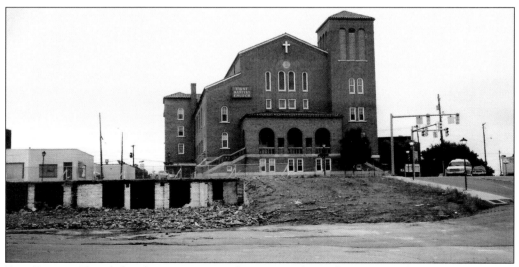

First Baptist Church has been sitting on the corner of Neville Street and First Avenue since 1929, with a seating capacity of 1,800. Initially, it was called Raleigh Baptist Church and was changed to First Baptist Church once the building was completed. The entire block facing the church had been businesses, which were razed in the late 1990s and early 2000s. The site is now Word Park.

During the 1950s and 1960s, Beckley enjoyed an amateur theater group called the Curtain Callers. These shots are from *Bus Stop*, performed in March 1960. Directed by Frankie Wheeler, the cast included Susie Harrah, Andy Jurisich, Jack White, Ruth Saymen, Danny Saks, Jim Wheeler, Sandy McKenzie, and Bernie Snead. Jim and Frankie Wheeler are professional artists as well.

John F. Kennedy campaigned from the Raleigh County Courthouse steps on April 11, 1960, and was accompanied by his wife, Jackie. When he was assassinated in 1963, hundreds of mourners attended a memorial service in the Methodist Temple.

Charles F. Shoemaker, shown with his wife, Hazel, served as mayor of Beckley from 1983 until his untimely death in 1988. Shoemaker Square is named in his memory. (Courtesy of Dick Klaus.)

Newly elected governor of West Virginia Hulett C. Smith is shown at the inaugural ball with his wife, Mary Alice (Tieche). Governor Smith is a native of Beckley and served from 1965 to 1969. (Courtesy of RCHS.)

Joe L. Smith Sr. was born in 1880 and became one of Beckley's icons. Smith was the editor, publisher, and owner of the *Raleigh Register* for 20 years and served as Beckley's mayor for nearly four terms, having resigned to begin his duties as congressman. In 1908, he was elected to the US House of Representatives, where he was assigned to the House Committee on Mines and Mining since his district produced more coal than any other congressional district in the nation. He held his role for 16 years, which was a record at that time. When Smith retired from politics, he spent time on numerous business ventures. He was the father of Joe L. Smith Jr. and Hulett C. Smith. (Courtesy of Raleigh County Public Library.)

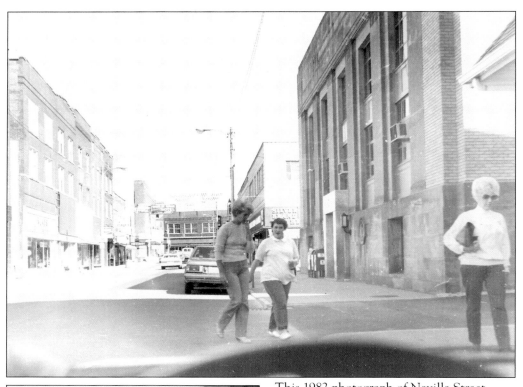

This 1982 photograph of Neville Street shows that downtown retail shops were disappearing as malls took over across America. (Courtesy of Robert Hancock.)

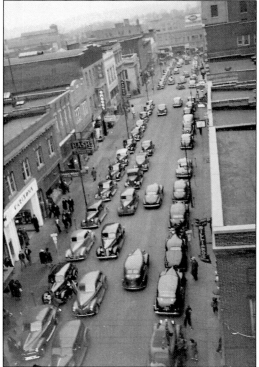

Taken from the top of the WJLS building, this 1941 photograph shows a charming view of Main Street on a Sunday morning. There were several churches in downtown Beckley and many people rode buses to town, while others were fortunate in driving a car. (Courtesy of Russ Parsons.)

The building with awnings was the former site of the Beckley Fire Department, and the tiny building to the right served as city hall until the 1960s, when a new facility was built just a short distance to the right. (Courtesy of Russ Parsons.)

Tommy Small, a Beckley native, won the West Virginia Welter Weight Boxing Championship in 1989 and was the WBF Junior Middle Weight World Champion in 1991, having fought 20 to 25 matches to become the world champion. His career began at age 23, and with no amateur boxing experience, he won his first match in Beckley in 1986. His boxing career carried him all over the world and his matches were televised nationally many times. Tommy fought on many cards with Evander Holyfield, Mike Tyson, Lenox Lewis, and many other top contenders. (Courtesy of Tommy Small.)

Construction began in 1982 on the United Methodist Temple. It sits near the site of former Skelton Elementary School, which was razed in 1950, a time when the entire coal camp community slowly began disappearing.

This photograph shows the beautiful United Methodist Temple, which was completed in 1983. (Courtesy of United Methodist Temple.)

This is what the view from United Methodist Temple looks like 25 years later. The former Skelton community has become a prime retail and amusement center.

Klaus Office Equipment Company was an icon in Beckley, having served Raleigh County and surrounding county businesses for 75 years before closing in 1997. The building is a Depression-era style. It was built in 1922 and is in the historic district on Neville Street. (Courtesy of Dick Klaus.)

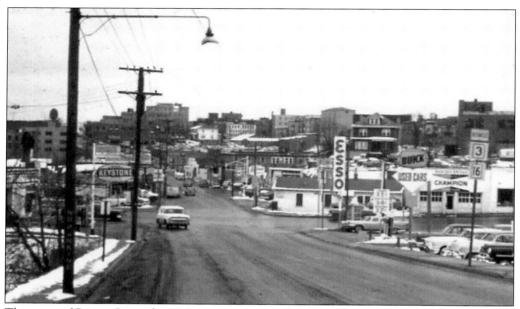

This view of Prince Street from Harper Road around 1958 shows a gas station on every corner. (Courtesy of Russ Parsons.)

This c. 1950 photograph of Lucas Tire Company vehicles was taken on the corner of West Neville Street and Harper Road. Lucas operated from the early 1940s until it was sold in 2005. (Courtesy of Raleigh County Public Library.)

Greater Beckley Christian School Bell Choir performed at Serendipity Coffeehouse on Neville Street after the big Christmas parade downtown in 1999. Serendipity was a great place for teenagers and young adults to showcase their musical talents from 1995 to 2001. The coffeehouse nurtured genius and fostered friendships. (Courtesy of Dick Klaus.)

Marion Meadows is seen relaxing at Serendipity Coffeehouse with a cigar and cappuccino in June 1997, when Beckley's music enthusiasts had the opportunity to meet the famous jazz saxophonist. Meadows had reached no. 3 on the jazz charts and had recorded four albums. He is a Mullens native and was in Beckley for a benefit performance for the Munster Project. (Courtesy of Dick Klaus.)

Little Jimmy Dickens, Grand Ole Opry star and native of Bolt, is pictured with Nancy Smith, owner of WJLS Radio. He came to Beckley to celebrate the 50th anniversary of WJLS in 1989. Dickens was one of the early live performers on WJLS radio in the 1940s. WJLS was sold in 2001. (Courtesy of Pete Torrico.)

The firefighter above the cloud of smoke is extinguishing Beckley's second big fire, which occurred on Heber Street in 1986. It destroyed two buildings, Ragland Law Offices and Lilly's Crown Jewelers. Damages were estimated at $2,000,000. Ironically, this is also where the great fire of 1912 occurred. (Courtesy of Kevin Price.)

Beckley Fire Department is shown training at the National Mine Academy. The dangers of fire fighting are real and the Beckley firefighters are well trained to deal with a multitude of life-threatening issues that occur during fires. (Courtesy of Kevin Price.)

The 1985 American Legion parade presented a thought-provoking entry, "Communism has and can demand payment in full for your freedom." (Courtesy of Dick Klaus.)

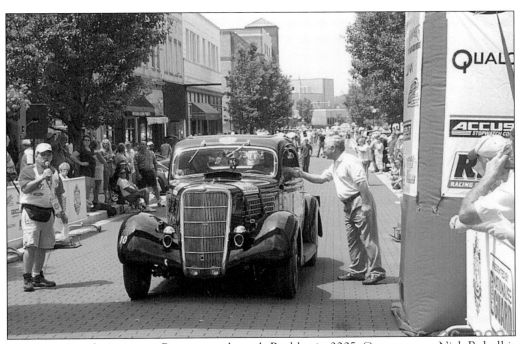

The Great North American Race came through Beckley in 2005. Congressman Nick Rahall is shown greeting the drivers on Neville Street as they traveled through the inflated tunnel with Royal Guards standing alongside. (Courtesy of Joe Guffy.)

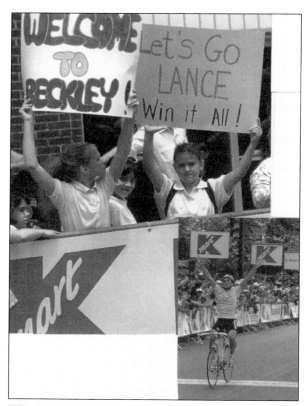

Beckley welcomed racers participating in the Kmart Classic of West Virginia on the 1994 Tour of America. Lance Armstrong was a strong crowd pleaser and the crowds roared as he passed by. (Courtesy of Pete Torrico.)

Prince Street was lined with excited people hoping to get a glance at Lance. All the bikers were cheered throughout the racecourse. (Courtesy of Beckley Renaissance.)

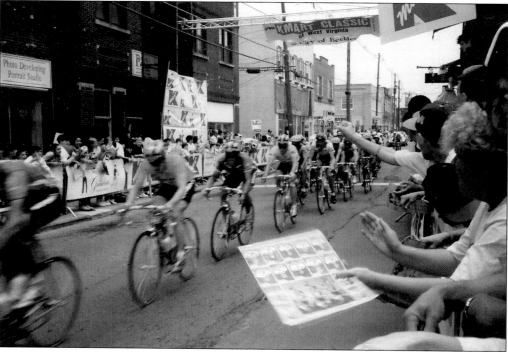

This photograph was taken on the final afternoon before all vehicular access to the Neville Street warehouses closed forever in 1995. Many retailers had little choice but to close their businesses once the municipal parking lot was closed for construction of the federal complex. (Courtesy of Dick Klaus.)

The federal complex structural beams offer a unique look from Prince Street to the warehouses on Neville Street. Construction began in 1995 and was completed in 1999. (Courtesy of Dick Klaus.)

The federal courthouse construction is shown here in 1996. The huge slab across the top had to be removed and returned to Canada as the provider had inverted the three S's in United States Courthouse and no one noticed until after the installation.

The changes Beckley has undergone since the founder first laid out his "Paper Town" would surely make him feel justifiably proud of his city, which has become the hub of southern West Virginia.

Six

THE END OF AN ERA

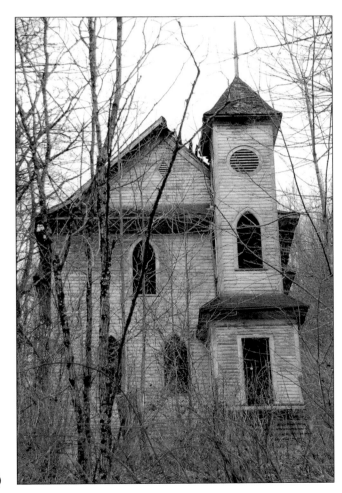

St. John's Baptist Church served the mining community in Stotesbury from the turn of the 20th century until 1990, when it stood dormant until its collapse in September 2009. This photograph gently whispers volumes about another time and another place in history. (Courtesy of RCHS; photograph by Steve Brightwell.)

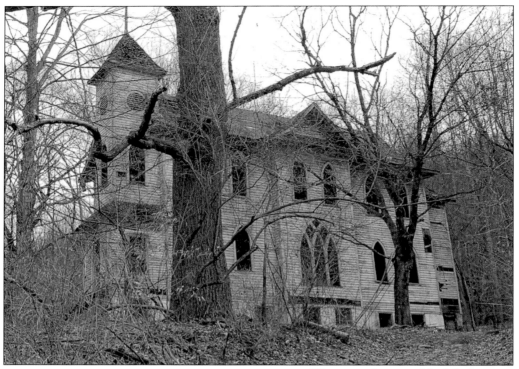

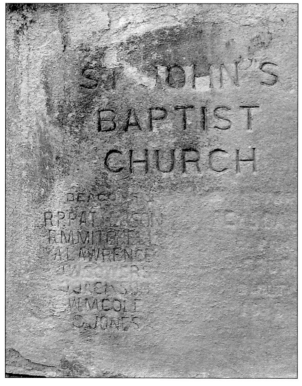

This is a side view of St. John's Baptist Church in Stotesbury. The beautiful architecture is reminiscent of a time when Sundays were truly days of rest, worship, and family gatherings. This was often the only day that children could be together with their fathers, who worked from dawn to dusk on every other day. (Courtesy of RCHS; photograph by Steve Brightwell.)

Time has taken its toll on the cornerstone of St. John's Baptist Church. Nearly every coal camp had a church, school, company store, doctor's office, post office, and baseball team. Everyone put on his or her Sunday best and families worshiped together. Mining was a very dangerous occupation and death was not a rarity in the coalmines, so giving thanks together every Sunday was never taken for granted. (Courtesy of RCHS; photograph by Steve Brightwell.)

This photograph shows a thought provoking overview of a small part of coal camp life in Stotesbury. This is where a sense of community was created by hard working miners and their families. All this has now vanished, leaving only memories of a bygone era. (Courtesy of RCHS; photograph by Steve Brightwell.)

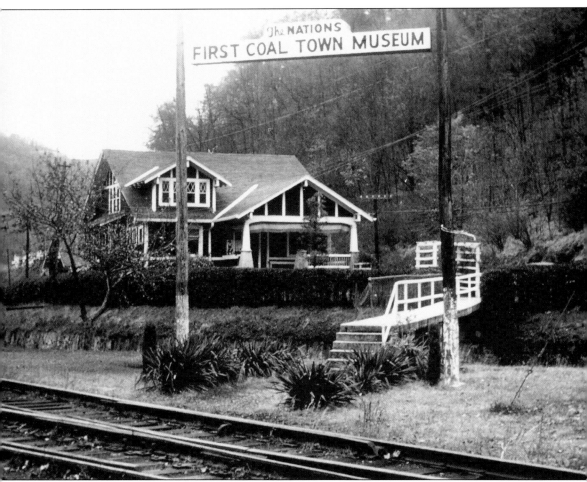

Stotesbury's population once stood at 2,000, and it was a thriving community in the heart of the southern West Virginia coalfields. E.E. White founded the Stotesbury operation in 1907. He began his career in the mines as a trapper boy and slowly advanced to the presidency of the leading producer of bituminous coal, earning him a measure of fame and fortune. Stotesbury, the nation's first coal town museum, displays a collection of artifacts and scenes, from mule-hauled coal cars to well-ventilated passageways, and electric powered coal trains. The museum offers visitors the opportunity to appreciate and gain knowledge of an era that helped build America.

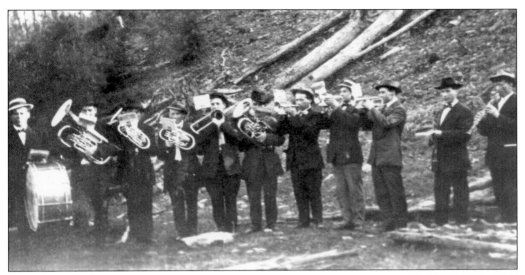

This photograph is said to be of the Stotesbury Orchestra around 1923. Many coal camp towns had their own orchestras composed of children and adults. Sundays during the summer months were typically times for picnics and musical entertainment. Coal company officials encouraged musical groups in nearly all camps.

Beckley Hospital's front entrance was quite dramatic in 1955. Obviously, only healthy folks would enter and exit through these doors. (Courtesy of Raleigh County Public Library.)

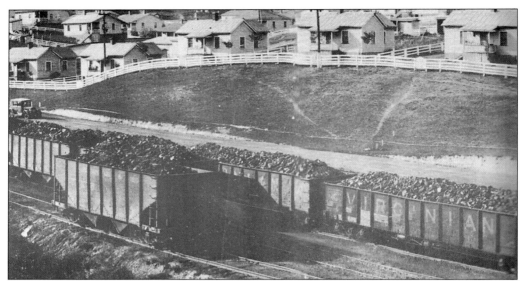

A small section of Cranberry is shown with its main product, smokeless coal. The community was well-maintained by its people, who took pride in their families, homes, gardens, and flowers. A true sense of community was established in Cranberry and other coal camps throughout the New River Company.

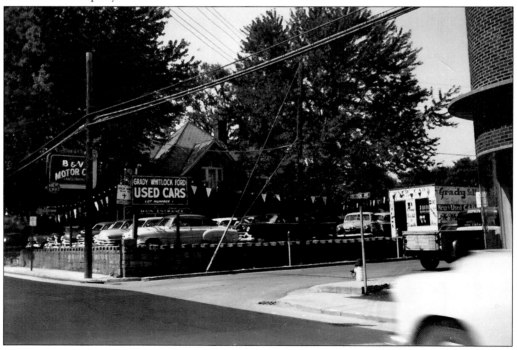

B&V Motor Company and Grady Whitlock Ford were on South Valley Drive (now Byrd Drive) in the 1940's. In 1954, Grady opened his own lot at 903 West Neville Street. In the 1960s, he built Grady Whitlock Ford on the corner of Eisenhower and Rural Acres Drives, which operated until the mid 1980s. (Courtesy of Raleigh County Public Library.)

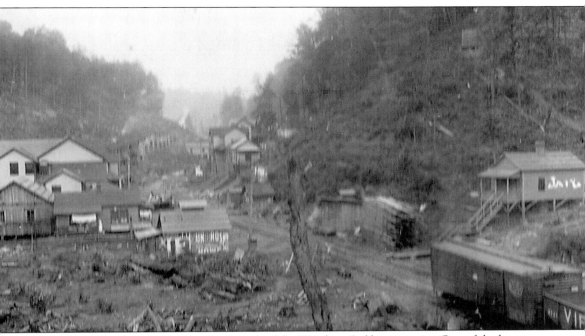

Notice the jail on the right in this photograph of the Winding Gulf community. One of the houses on the left has fresh laundry hung out to dry. Anything white was soon a gray color thanks to the perpetual soot and cinders. (Courtesy of Russ Parsons.)

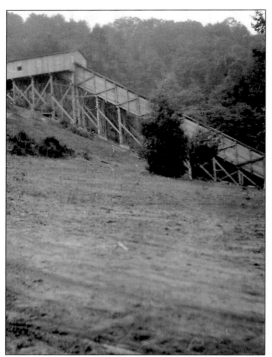

This wooden tipple is thought to have been at Daniels. These structures have appeared all over southern West Virginia. At one time, there were said to have been 500 coal mines between Beckley and Bluefield. (Courtesy of Russ Parsons.)

Another unidentified wooden tipple occupies a mountainside in Raleigh County. Hardwood was used in earlier coal mining since it was locally available, cheap, and did the job. In the 1920s, steel beams were brought in and tipple construction improved.

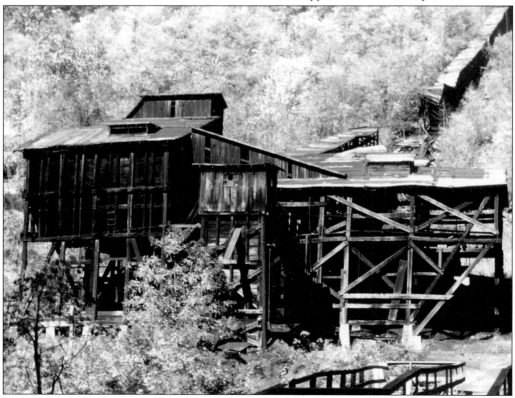

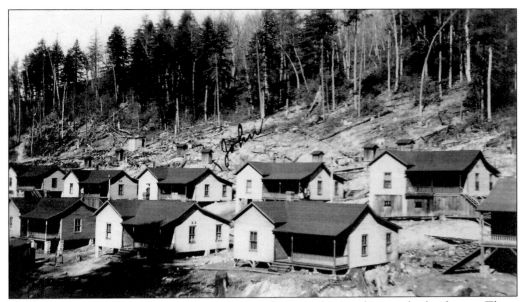

This Winding Gulf Coal Company community shows outhouses dotting the landscape. These houses were set on more narrow land than many other communities, but with the hillside and rough terrain, this was a typical layout. (Courtesy of Russ Parsons.)

Brothers A.K. Minter (left) and E.C. Minter (right) are shown with two unidentified men. E.C. Minter owned Minter Fuel Company, which consisted of several mines in the Winding Gulf region and Frances Coal Mine in Rhodell. A.K. Minter Sr. was superintendent of these mines in the 1930s and served as mayor of Beckley from 1938 to 1943 and again from 1956 to 1959. Following in the footsteps of his grandfather, Emmett S. Pugh III has served as Beckley's mayor since 1988. (Courtesy of Colette Minter Meadows.)

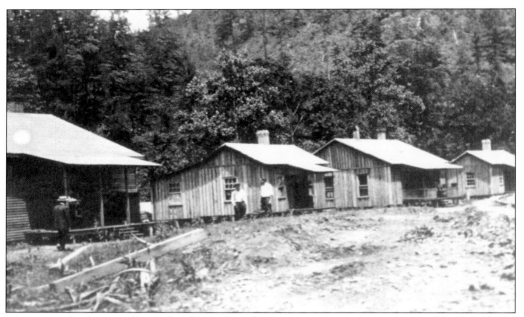

These tiny shacks served as shelter for workers during the young timber industry of the late 1800s, as the Industrial Age was approaching. (Courtesy of RCHS.)

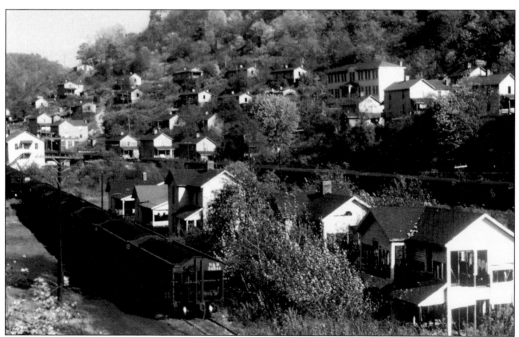

This photograph shows another long forgotten coal camp in Raleigh County. One of the most trying things that coal camps had in common was that railroads ran along the rows of houses. The roar of the trains, soot, smoke, and cinders were perpetual, but there was no other choice but to endure. These were tough times, but the people were tougher.

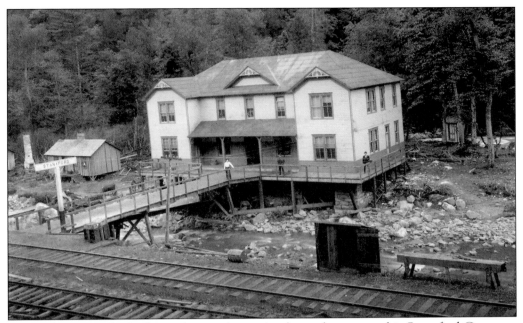

One had to cross the bridge with a creek running beneath to enter this Stanaford Company Store. Notice the outhouse to the right and the small houses to the left. Deliveries to this store must have been challenging. (Courtesy of Russ Parsons.)

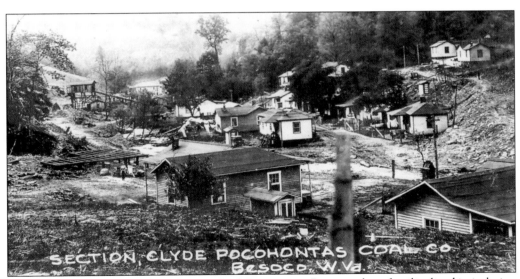

This is the Clyde Section of Pocahontas Coal Company in Besoco, where families lived in isolation until the railroads and busses gave them an opportunity to shop in town instead of the company store, although the company officials frowned on this practice. (Courtesy Russ Parsons.)

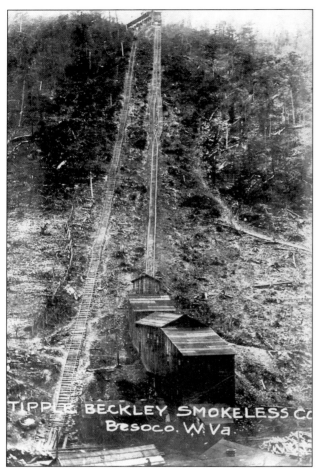

This c. 1910 photograph shows another wooden tipple in Besoco. (Courtesy of Russ Parsons.)

This photograph was taken on May 2, 1915, from the platform of the Winding Gulf Company Store. Notice the folks walking on the railroad tracks. These were familiar sights in southern West Virginia until the 1950s, when pick-and-shovel coal mining was quickly grinding to a halt. (Courtesy of Russ Parsons.)

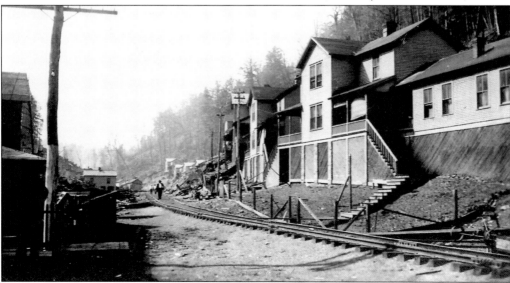

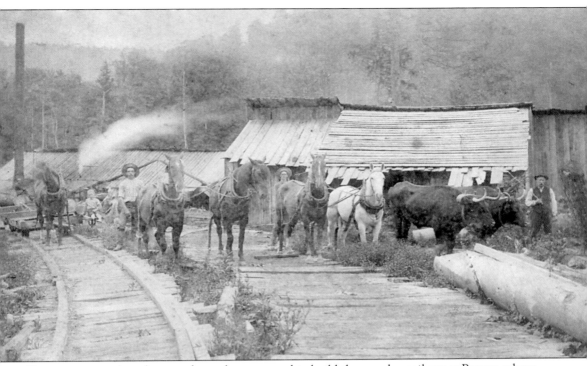

Horses, oxen, mules, plows, and muscles were used to build the wooden railway at Beaver, where Ritter Lumber Company operated its mill. The railway opened the door to vast opportunities for lumber mills across a state filled with virgin hardwood forests. (Courtesy of RCHS.)

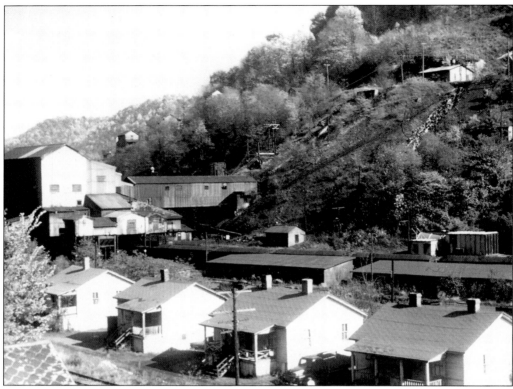

McAlpin Coal Camp is another piece of history. Memories remain with those who lived, worked, played, prayed, learned, and formed lifelong friendships in the tiny coal camp houses with great big hearts. Many coal camps date from the 1880s to the 1950s, and most have completely vanished. Those coal camps that are in urban and wilderness areas have survived fairly well.

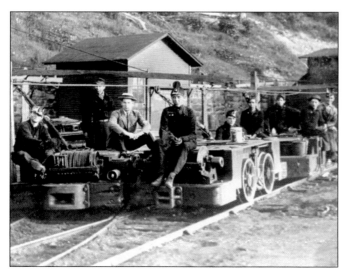

The electric mine locomotive relieved the mules of their jobs in 1913. The mantrip motorcar was powered by electricity that was generated by substations near the coal mine. Notice the steel cable atop the cars. The carbide lamps eventually replaced the oil-burning lamps, also known as lard lamps, on the miners' hard hats. The carbide lamps provided far better illumination for the coal miners working in the dangerous pitch black holes beneath the earth.

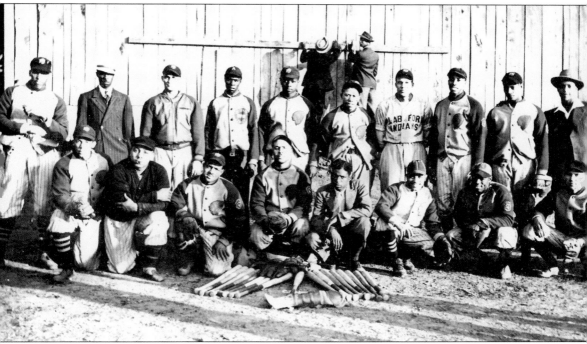

This is a rare photograph of the Slab Fork Indians Negro League baseball team at Slab Fork during the 1930s. Many coal camp officials emphasized baseball in their towns, providing a field for playing against other teams who might travel by train or bus to play on Sunday afternoons. (Courtesy of Russ Parsons.)

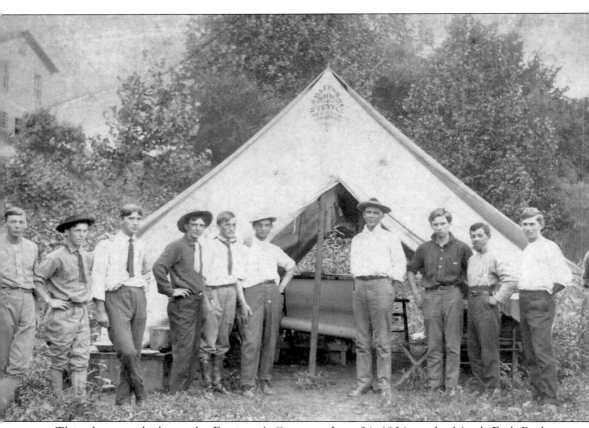

This photograph shows the Engineer's Camp on June 24, 1906, at the Marsh Fork Railway construction site. The company was based in Rome, West Virginia. (Courtesy of RCHS.)

Seven

SKELTON COAL CAMP

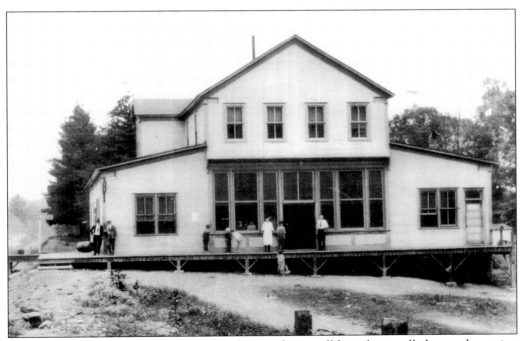

This relatively small company store at Skelton might as well have been called an early version of a mall. It sold groceries, meats, clothing, appliances, dry goods, and a host of other seasonal merchandise. It also held a post office, scrip office, doctor's office, superintendent's office, and store manager's office. The store opened in 1906 and once the mine closed in 1957, the store closed shortly thereafter and sat vacant. In 1971, Tracy Hylton purchased it and used it to store seedlings. The building was razed in 1974.

The Skelton Community Building sat at what is now the busiest intersection in West Virginia. It was used as a multipurpose building, a church and Sunday school, and town hall until around 1957, when the mine closed. Later, the locals used it as a Methodist church. The building was razed in the 1960s. (Courtesy of Robert Hancock.)

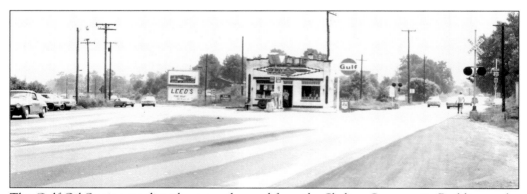

The Gulf Oil Station sat directly across the road from the Skelton Community Building at the intersection of present-day Eisenhower Drive and Robert C. Byrd Drive. Wilson Hamilton, father of June Watts, managed the station until the 1940s. Clyde Casey managed it until it closed around 1980.

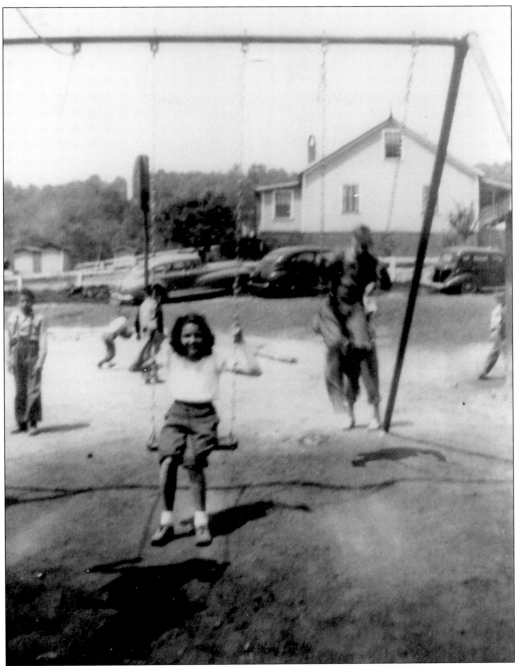

Mary Catherine Walker is shown on the swing at Skelton Elementary in 1945. Notice the dirt basketball court. Teachers parked along the fence of Lucy Woods, who ran the boarding house seen in the background. (Courtesy of Robert Hancock.)

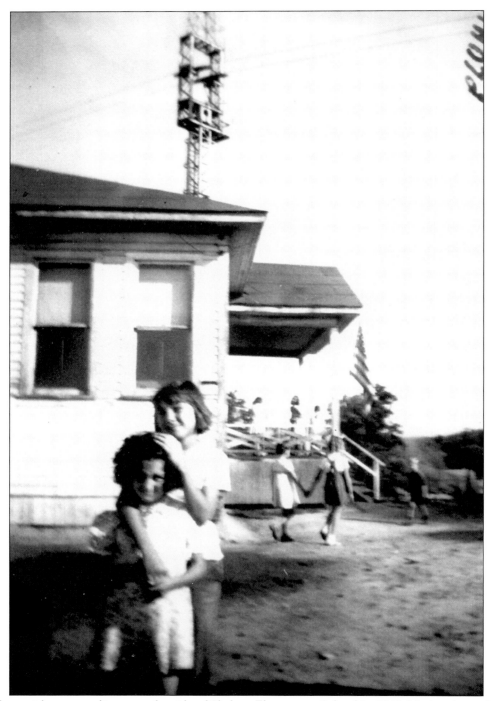

These girls are standing near the side of Skelton Elementary School in 1945. Notice the aerial tramway over the top of the schoolhouse. The tram was used to carry slate from the tipple to an enormous slate pile that sat at the back of where L&S Toyota now sits. Sulfur fumes were always in the air. After it rained, the odor was excessively strong. (Courtesy of Robert Hancock.)

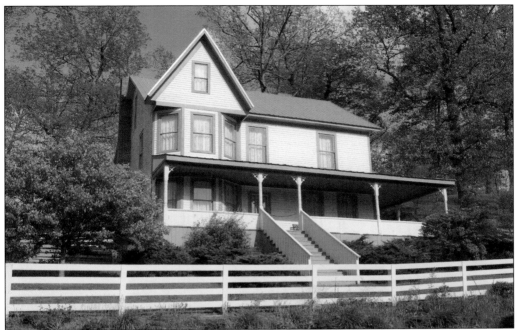

The Skelton mine superintendent's house was constructed in 1906. It was always referred to as the super's house. Resembling a small mansion, it was built by Samuel Dixon to look like his countryside home in Skelton, England. The three-story structure was dismantled by the City of Beckley in 1994, and it was reconstructed and restored in 1995 to its former grandeur on the former Sprague mine site at the Beckley Exhibition Coal Mine.

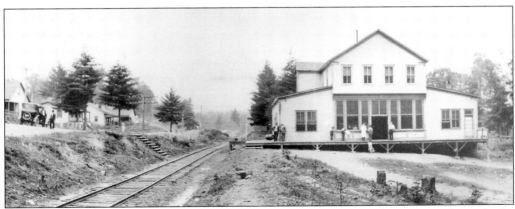

This is a small glimpse of the housing at Skelton, with the railroad tracks running alongside the road where C&O Railroad routinely delivered supplies to the company store. This was a time when coal was king and many "owed their soul to the company store," as Tennessee Ernie Ford put it. The Skelton community took pride in its neatness. Flowers and gardens were found on everyone's property and yard and garden officials awarded prizes for the finest Victory Gardens.

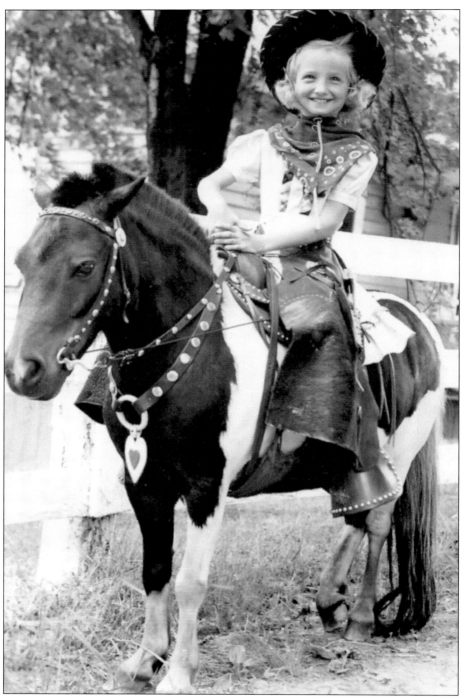

Every kid in Skelton had to have a photograph taken on this pony that traveled throughout the coalfields, earning $5 for every photograph. Galvin Studios from Charlotte, North Carolina, came every summer, offering this golden opportunity. Families sacrificed so each child could have this memory. Shown in this 1947 photograph is author Fran Duran (Klaus).

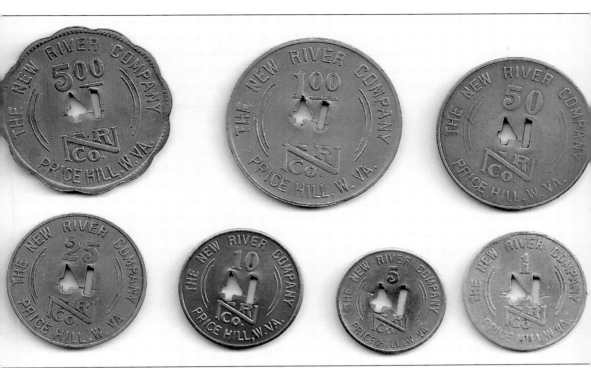

Scrip, sometimes called token money, was issued by the New River Company to pay miners. This was very profitable for the mining companies as it was used as an advance against wages and was good only at the company store, where prices were high and there was no competition. Miners paid rent to live in company houses and paid for their own tools and blasting caps, doctor bills, and electricity from company substations, and earned less than $1 an hour. The miners always had to borrow against their wages, leaving very little for a draw on payday. Each company store had a number cut into the center of the coins. Skelton's number was nine and it had to be spent at the Skelton store. The coins were made of copper, brass, bronze, nickel, wood, zinc, or aluminum. Each denomination was a different material. The collection shown here is from the Price Hill.

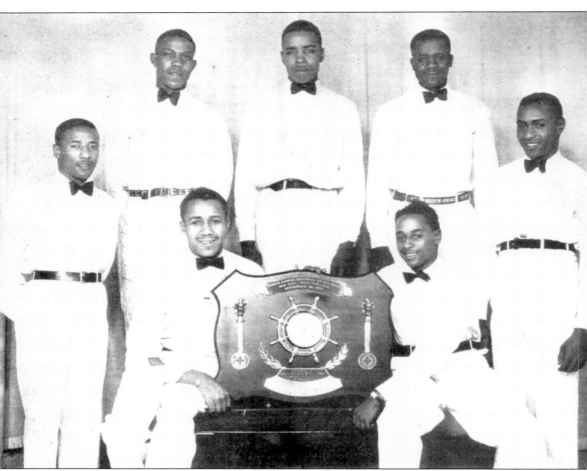

In 1937, the Skelton Colored First Aid Team became state champions of West Virginia, competing against 19 other teams. The team members are, from left to right, (sitting) James Anderson and Carl Brown; (standing) W.J. Brown, W.E. Brown, Johnnie Lawson, Eli Williams, and Marion Brown. The New River and Winding Gulf Mining Institute awarded the plaque to the team. (Courtesy of Robert Hancock.)

Ration stamps were issued to Americans in 1943, when shortages of nearly everything were endured due to World War II. Every American had to follow the rationing system and do what they could to help pay for the war. Patriotism was not just a word, it was an action. (Courtesy of Dick Klaus.)

There was no beating the system in 1943. The motto for this time period was, "If you do not need it, do not buy it." Anyone who could work did so. Remember Rosie the Riveter? Women stepped up to help fill the void left in the workforce when so many of our men headed off to war. They did it then. Could we do it again? You bet!

RATION STAMP NO. 1	RATION STAMP NO. 2	RATION STAMP NO. 3	RATION STAMP NO. 4
RATION STAMP NO. 5	RATION STAMP NO. 6	RATION STAMP NO. 7	RATION STAMP NO. 8
RATION STAMP NO. 9	RATION STAMP NO. 10	RATION STAMP NO. 11	RATION STAMP NO. 12
RATION STAMP NO. 13	RATION STAMP NO. 14	RATION STAMP NO. 15	RATION STAMP NO. 16
RATION STAMP NO. 17	RATION STAMP NO. 18	RATION STAMP NO. 19	RATION STAMP NO. 20
RATION STAMP NO. 21	RATION STAMP NO. 22	RATION STAMP NO. 23	RATION STAMP NO. 24
RATION STAMP NO. 25	RATION STAMP NO. 26	RATION STAMP NO. 27	RATION STAMP NO. 28
RATION STAMP NO. 29	RATION STAMP NO. 30	RATION STAMP NO. 31	RATION STAMP NO. 32
RATION STAMP NO. 33	RATION STAMP NO. 34	RATION STAMP NO. 35	RATION STAMP NO. 36
RATION STAMP NO. 37	RATION STAMP NO. 38	RATION STAMP NO. 39	RATION STAMP NO. 40
RATION STAMP NO. 41	RATION STAMP NO. 42	RATION STAMP NO. 43	RATION STAMP NO. 44
RATION STAMP NO. 45	RATION STAMP NO. 46	RATION STAMP NO. 47	RATION STAMP NO. 48

INSTRUCTIONS

1 This book is valuable. Do not lose it.

2 Each stamp authorizes you to purchase rationed goods in the quantities and at the times designated by the Office of Price Administration. Without the stamps you will be unable to purchase those goods.

3 Detailed instructions concerning the use of the book and the stamps will be issued. Watch for those instructions so that you will know how to use your book and stamps. Your Local War Price and Rationing Board can give you full information.

4 Do not throw this book away when all of the stamps have been used, or when the time for their use has expired. You may be required to present this book when you apply for subsequent books.

Rationing is a vital part of your country's war effort. Any attempt to violate the rules is an effort to deny someone his share and will create hardship and help the enemy.

This book is your Government's assurance of your right to buy your fair share of certain goods made scarce by war. Price ceilings have also been established for your protection. Dealers must post these prices conspicuously. Don't pay more.

Give your whole support to rationing and thereby conserve our vital goods. Be guided by the rule:

"If you don't need it, DON'T BUY IT."

16—32290-1 ☆ U. S. GOVERNMENT PRINTING OFFICE : 1943

 308732 **CW**

<small>UNITED STATES OF AMERICA
OFFICE OF PRICE ADMINISTRATION</small>

WAR RATION BOOK No. 3

Void if altered

NOT VALID WITHOUT STAMP

Identification of person to whom issued: PRINT IN FULL

_____ _____ _____
(First name) (Middle name) (Last name)

Street number or rural route _____

City or post office _____ State _____

AGE	SEX	WEIGHT	HEIGHT	OCCUPATION
43	Male	189 Lbs.	5 Ft. 11 In.	Miner

SIGNATURE _____
(Person to whom book is issued. If such person is unable to sign because of age or incapacity, another may sign in his behalf.)

WARNING
This book is the property of the United States Government. It is unlawful to sell it to any other person, or to use it or permit anyone else to use it, except to obtain rationed goods in accordance with regulations of the Office of Price Administration. Any person who finds a lost War Ration Book must return it to the War Price and Rationing Board which issued it. Persons who violate rationing regulations are subject to $10,000 fine or imprisonment, or both.

LOCAL BOARD ACTION

Issued by _____
(Local board number) (Date)

Street address _____

City _____ State _____

(Signature of issuing officer)

OPA Form No. R-130

This war ration book contained eight sheets of ration stamps, 1 through 48. This may have been allotting two sheets per week in purchasing power. Nearly everyone had a large garden and canned most of their vegetables and fruits to last an entire season, and nearly everyone had chickens and hogs in a pen that was kept in the nearby woods. People were resilient and hard working. No individual depended on anyone else to take care of him or her. They worked, planted, harvested, canned, and stored for their own needs.

Hot, hungry, and exhausted describes a miner's return home after a long, grueling day working in the coal mine. This photograph is of Mike Duran, whose coal mining career began at age 8, when he came to America with his father. He helped earn enough money to send to his family left behind in Czechoslovakia to keep them from starving, as communism had taken their vast farmlands and the country was destitute. Sending their youngest son to America to work provided a much needed second paycheck, but at such a price for the young lad. Mike is shown with his son Tom in 1953.

This 1948 photograph shows Mike and Mary Duran, immigrants from Czechoslovakia, on a Sunday afternoon in the front yard of their Skelton company house. This is about the only day of the week that miners wore dress clothes, their faces were not ringed with coal dust, and their children could actually spend a little time with their fathers. The entire neighborhood knew when Mrs. Duran baked her weekly loaves of bread, as the scent in the air throughout the community caused mouths to water.

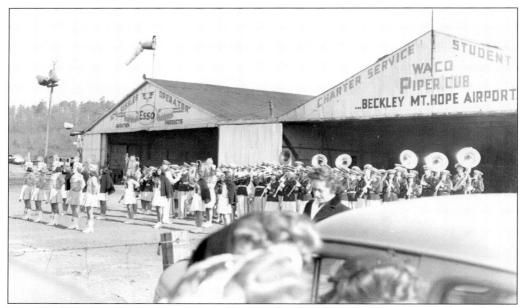

The 1939 Woodrow Wilson Flying Eagle Band, under the direction of Glenn Sallack, performed at the Beckley–Mount Hope Airport for the opening of the biggest air show in Beckley's history. Over 20,000 people arrived to watch the attraction.

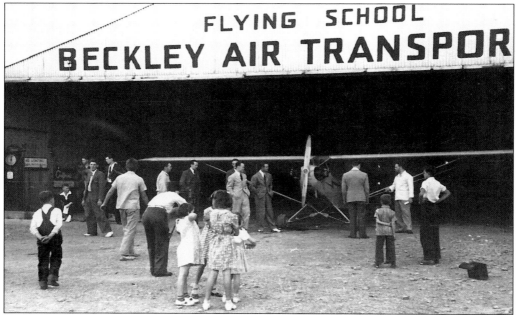

The lure of the air drew spectators from afar to watch the air show at the Beckley–Mount Hope Airport, sometimes referred to as Scott Field. The airport was dedicated in September 1937, and continued serving the area until the new Raleigh County Memorial Airport opened in 1952. The Beckley Plaza Shopping Center now stands on the former airport strip. In 1935, Tolley Field, a rolling cow pasture on Johnstown Road, was used as an airport prior to the development of Scott Field.

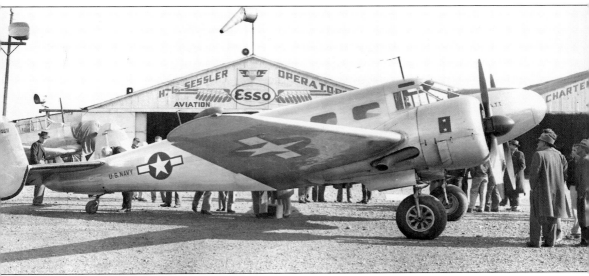

One of the first twin-engine planes to land in Beckley drew a huge crowd in 1946, when this US Navy plane landed at the Beckley–Mount Hope Airport. The Navy thrilled a huge crowd as the new jets flew over Beckley for one hour and then flew off to the wild blue yonder.

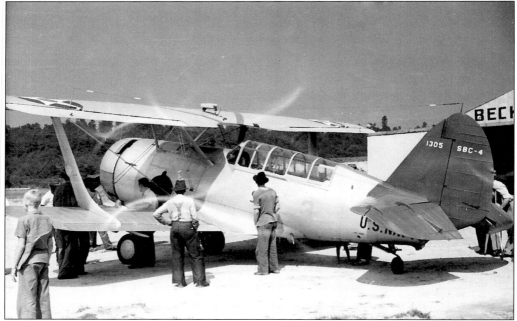

Airplanes remained an exciting attraction in the 1930s and 1940s. Skelton Airport drew crowds any time a plane landed. This US Navy two-seater, double-wing plane from World War II landed in Beckley in 1946.

This was yet another mesmerizing airplane to inspect and watch fly off in 1946. One thing that Skelton coal camp can boast about is that it was the only coal camp in Raleigh County with an airport.

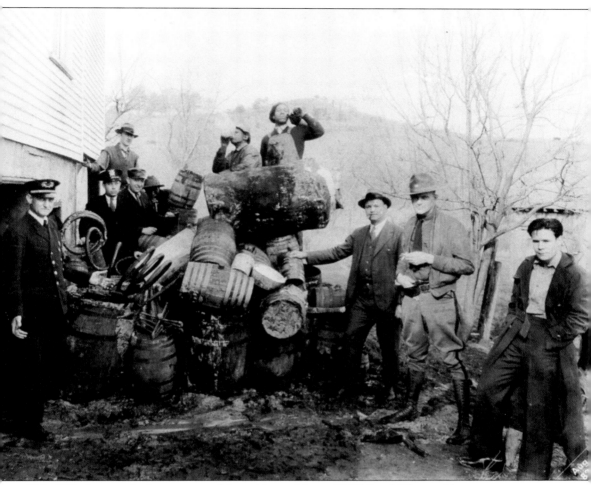

This 1929 photograph shows a moonshine raid near Maxwell Hill Road. These raids were common during the Prohibition era and even beyond. The young man to the far right is Lewin Wilkes, who opened Wilkes Insurance on the top floor of E.M. Payne Company on Main Street. The insurance agency later moved to South Fayette Street, where it remained family-owned until it closed in the 1990s. (Courtesy Betty Wilkes.)

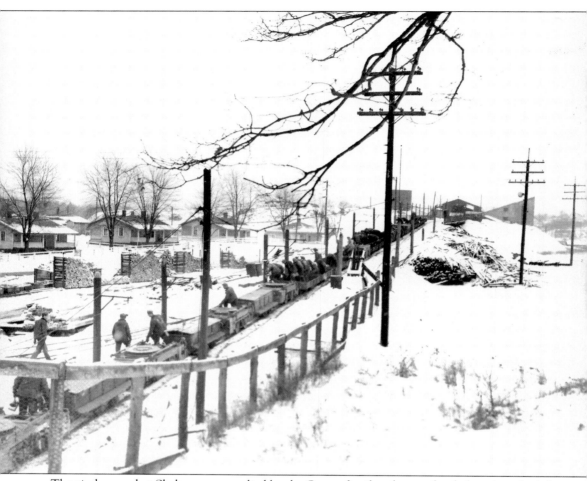

The timber yard at Skelton was supplied by the Stover family, who cut, hauled, and stacked the timber to be used to support the roof of the mine where men often worked on their knees in 36-inch heights or less. Miners would have to lay on their backs to place the dynamite, crawl to a protected area, go back and dig the coal with pick and shovel, and then load the coal into a coal car and secure a brass coal check number to the cart in order to get paid for the load, then begin the process all over.

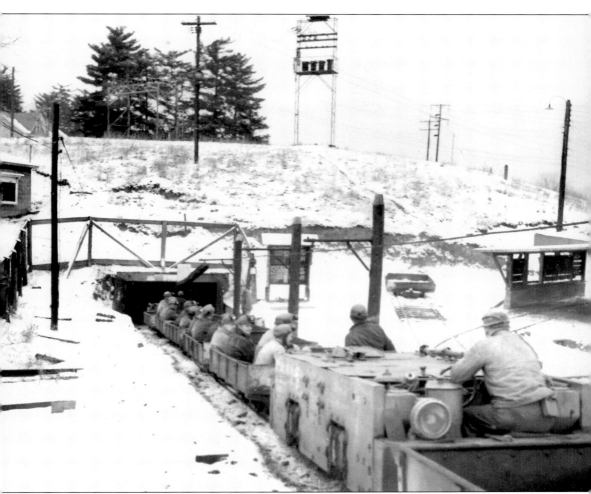

This day shift begins another grueling day beneath the surface at the Skelton Mine in 1947. At that time, miners earned $3.25 per day plus 79.2¢ per ton of coal. If a miner hit rock he still had to load it, but did not get paid for it. Miners paid for the dynamite used to loosen the coal. Typically, a miner would load 15 to 20 tons of coal each day.

The property that once sat as useless swampland was filled with slate to stabilize the acreage on Eisenhower Drive in the 1990s. It is now one of the biggest shopping centers in southern West Virginia. The swampland is now swamped with businesses and shoppers.

Eight

A New Day Dawns

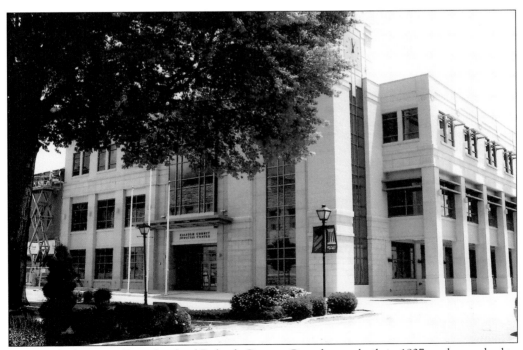

Time had taken its toll on the third Raleigh County Courthouse, built in 1937, and room had to be allocated for the overcrowded spaces. The Heber Street block and corner of Main Street were razed to accommodate the new government facility. Directly across the street from the courthouse is the new Raleigh County Judicial Annex, nearing completion. It is expected to open by the end of 2011. The building will house three judicial courtrooms for the circuit judges, along with offices for magistrates and circuit clerks. The cost for the annex is $17,500,000.

It's The **Beginning** of the next 100 years of Scouting.

The Bechtel Family National Scouting Reserve, also called The Summit, sits on 10,600 acres of land adjoining the New River Gorge and US 19. An adventure center, operated by the Boy Scouts of America and a permanent home of the National Scout Jamboree, is set to open in 2013. It will serve as the location of a summer camp, high adventure base, and a leadership training center. It is expected that 50,000 to 100,000 boy scouts will visit the site annually. The Reserve sits in a centralized location in the eastern United States near Interstates 77 and 64. This facility will have a huge economic impact for Beckley and the surrounding areas. The future is in good hands. (Courtesy BSA Jamboree.)

Beckley-Raleigh County Chamber of Commerce

The quiet of a small town, the solace of a mountain farm, and the vigor of a city neighborhood are all found in Raleigh County. Five state parks and four wildlife management areas provide fishing, boating, kayaking, whitewater rafting, rock climbing, and hiking. Golfers are within an hour of 17 courses, including the world famous Greenbrier Resort. Glade Springs Resort courses rank among West Virginia's top courses. Game hunting is a way of life here; one will find advanced facilities and cabins throughout the area. Trail systems make Raleigh County a destination for bikers and hikers, and our most recent Burning Rock Trail is drawing thousands of ATV riders from all over the country. Winterplace Ski Resort is just two minutes off Interstate 77. You will find "The Best of West Virginia" handcrafted items by juried artisans at Tamarack. Beckley Exhibition Coal Mine carries visitors underground to an actual coal mine. Theater West Virginia is the longest running outdoor Civil War drama in the nation. Beckley Art Group exhibits year-round at the Cynthia Bickey Art Center. Raleigh County is at the crossroads of several major interstates and highways and offers air service at the Raleigh County Airport. Contact us at 1-877-987-3847 or chamber@brccc.com..

Discover Thousands of Local History Books
Featuring Millions of Vintage Images

Arcadia Publishing, the leading local history publisher in the United States, is committed to making history accessible and meaningful through publishing books that celebrate and preserve the heritage of America's people and places.

Find more books like this at
www.arcadiapublishing.com

Search for your hometown history, your old stomping grounds, and even your favorite sports team.

Consistent with our mission to preserve history on a local level, this book was printed in South Carolina on American-made paper and manufactured entirely in the United States. Products carrying the accredited Forest Stewardship Council (FSC) label are printed on 100 percent FSC-certified paper.

MADE IN THE USA